IMAGES
of America

FOREST PARK

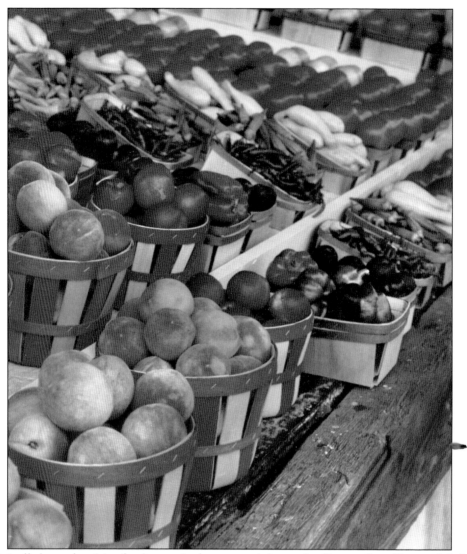

Originally located on Murphy Avenue in downtown Atlanta, the Georgia State Farmers Market moved to Forest Park in 1958. It is open 7 days a week, 364 days a year, and approximately 3,500 people a day find fresh fruits and vegetables, international spices, basket wholesalers, a restaurant, and a welcome center. In addition, the market is the distribution hub for the Southeast and eastern seaboard and contributes a direct economic impact of approximately $3 billion overall. (Courtesy of Murphy and Orr Exhibits.)

ON THE COVER: Engine 1558 ran from Atlanta to Jonesboro, stopping at several towns along the way, including Forrest Station. In the train's earliest days, Forrest Station was a mail drop. The mail would be thrown from the train for someone to pick up, or the train would be flagged down in order for outgoing mail to be tossed on board. Gradually Forrest Station became a regular stop for the railroad, and citizens throughout the area rode the train to Atlanta to work and shop. Engine 1558 was affectionately called the "Dummy," because the end of the line at Jonesboro had no roundhouse; therefore, the train had to run part of its route backwards. (Courtesy of Jeanelle Smith Fleming.)

IMAGES
of America

FOREST PARK

Christine Terrell, Beverly Martin,
and Steve Pearson

ARCADIA
PUBLISHING

Published by Arcadia Publishing
Charleston SC, Chicago IL, Portsmouth NH, San Francisco CA

Printed in the United States of America

Library of Congress Catalog Card Number: 2008923481

For all general information contact Arcadia Publishing at:
Telephone 843-853-2070
Fax 843-853-0044
E-mail sales@arcadiapublishing.com
For customer service and orders:
Toll-Free 1-888-313-2665

Visit us on the Internet at www.arcadiapublishing.com

We have lost several dear friends during the writing of this book. These individuals were very instrumental in making Forest Park the great city it has become. Their love and dedication is still being felt by people of all walks of life. The roles they played included teachers, preachers, business leaders, elected officials, moms, dads, friends, and anything else we needed them to be. Our book is lovingly dedicated to the memory of these individuals and their families, from our hearts to yours. That reminds me of a story I heard about the city of Forest Park.

CONTENTS

ACKNOWLEDGMENTS

A lot of information was needed before this book could be published. Past and present citizens came forth graciously, offering pictures, stories, mementoes, and help in any form needed. We gratefully appreciate those individuals and regret those we missed. Individuals unable to help because of their present location or health issues provided support in other ways, thanks to cyberspace. We could not fit everything we received into this book, but we hope we chose a combination that will show off our city in the best light possible.

A personal apology is due to those who were asked to contribute to this book but were not scheduled for a meeting. Many unforeseen events happened in the writing process, including illnesses and deaths. We will still be collecting photographs and stories for the Forest Park History Museum, so we will be calling again.

A note of apology is also necessary to the family members, friends, and citizens who had to hear us talk about this book for almost a year. We sincerely regret any anguish we might have caused anyone. It has always been our intention to build up anticipation and excitement leading up to the publication of our book and to our city's 100th birthday celebration in August 2008.

INTRODUCTION

Clayton County was created by an act of the state legislature on November 30, 1858, from parts of Henry and Fayette Counties. When formed, the county was part of the Treaty of Indian Springs, which was signed on January 8, 1821. At that time, the area now known as Forest Park, Georgia, was populated by the Creeks.

Clayton County was named in honor of Judge Augustin Smith Clayton, a distinguished Georgia attorney and U.S. congressman from Athens, Georgia. Although Judge Clayton never saw our land, we are proud to be home to one of his descendants, Dr. Don Ford, DVM.

We begin our journey in the mid-1800s with the Creeks, making some quick stops along the way to 1908, when today's Forest Park was born. Our destination being reached, we will shop, eat, worship, travel, and more with our city's first settlers.

Located in northern Clayton County, Forest Park is the county's largest city. We are a diverse community made up of approximately 22,000 individuals working together to make Forest Park an exciting and beautiful city in which to live and work.

We are comfortably nestled in a 9.3-square-mile area with convenient access to I-75, I-85, I-675, I-285, and the Hartsfield-Jackson International Airport, as well as being nine miles south of our state capital, Atlanta.

AREAS OF INTEREST:

THE HARTSFIELD-JACKSON INTERNATIONAL AIRPORT
Located three miles west of Forest Park, the Hartsfield-Jackson International Airport is the busiest passenger airport in the world.

ATLANTA, GEORGIA
Names like Terminus (1842), Marthasville (to honor Gov. Wilson Lumpkin's daughter), and finally Atlanta (incorporated as a city December 29, 1845) have been used to identify the city we have known as Georgia's state capital since April 20, 1868. With a population of over 416,000 people, Atlanta offers residents in and out of the city a wide variety of activities. Forest Park residents are able to enjoy restaurants, theater, shopping, the Atlanta Zoo, the Georgia Aquarium, the Martin Luther King Jr. Center, the Woodruff Arts Center, and much more by traveling approximately 20 miles from home. Have you ever heard of a varsity dog? Fifteen minutes after leaving Forest Park, you can be enjoying one with an order of onion rings and a frosted orange. How about a peach pie à la mode with that?

Business opportunities abound in downtown Atlanta. Whether you're a corporate executive or a blue-collar worker, there is something for you in the city of Atlanta. Some of the corporations with their world headquarters in Atlanta include AFLAC Insurance, Newell Rubbermaid, U.S. Centers for Disease Control, Gulfstream Aerospace, and CIBA Vision, not to mention our own Georgia Pacific, Home Depot, Coca-Cola, and Delta Airlines, the newly crowned largest airline in the world.

Forest Park offers an affordable and convenient option to downtown living. A person can stroll down a tree-lined street, own a nice home on a large lot where the kids can safely play, and still be close to cultural and employment opportunities offered in Atlanta.

INTERSTATE HIGHWAY SYSTEM

With our convenience to I-75, I-85, I-675, and I-285, Forest Park is being called Atlanta's best kept secret and a diamond in the rough. Within five minutes, you can be on one of the major interstate highways leading anywhere you wish to go, or you can take the scenic route on a beautiful state highway, exploring back roads and small towns along the way. Traffic congestion is light in our area, allowing for speed-limit drives. Our highways are well maintained and beautifully landscaped, making your drive less stressful.

FORT GILLEM

Another attribute to our city's growth and longevity is Fort Gillem Military Reservation, whose duties included training thousands of supply soldiers and maintaining and processing tons of equipment used in every major conflict since World War II.

OTHER ATTRACTIONS

Attributes to the city continue with the recent additions of the U.S. National Archives Southeast Region and the Georgia State Archives, both located approximately one mile from the Forest Park city limit. Clayton State College, a fully accredited university, is also located approximately two miles from our city limits.

Forest Park and the surrounding areas are seeing growth and making plans for future growth, including upscale dining and shopping areas and an airplane museum, and as the closing of Fort Gillem draws near, plans are being cultivated for that area.

One

YANKEE SOLDIERS IN FOREST PARK

Although not a major battle site, Forest Park saw heavy military action during the Civil War, and the war had a huge impact on Forest Park. Following his occupation of Atlanta, General Sherman issued Military Order No. 67 on September 4, 1864. This order stated that unless they had a trade that would benefit the Northern troops, all civilian residents of Atlanta had to evacuate their homes. Most residents fled their homes prior to Sherman's occupation. Many of those who stayed were infirm or too old to travel. They were given two choices: they could either pledge their allegiance to the North, never seeing their homes or family again, or they could be transported south by Union soldiers to a Confederate-held territory located below Lovejoy. The following helps confirm the town's involvement:

> HEADQUARTERS THIRD DIV.—TWENTY-THIRD ARMY CORPS, Aug 31, 1864, Major General Schofield, Commanding Officer.
>
> General: I am at Thames's house. A Little cavalry in front, making it necessary to deploy some skirmishers. It is one mile and a half to the railroad by nearest road, which forks about half a mile beyond to the left. It is a half a mile farther by the right fork of the road. I suppose you desire me to take the right fork so as to keep near 4th Corps. Mr. THAMES says Stanley cannot strike the railroad less than three miles below where I shall reach it by the right hand road.
>
> —Brig. Gen. J. D. Cox
> *War of the Rebellion*, Series I, Vol. 38.

A historical marker at the intersection of Thames Road (now Forest Parkway) and Clark Howell Highway, quoted by the USGenWeb Project, reads, "31 Aug. 1864, Troops of the 23rd and 4th AC (F), marching east from Red Oak, passed this house in route to the Macon and Western Railroad, which was seized at points above and below Quick Station (now Forest Park). This move severed the last of the RR entering Atlanta and forced General Hood to abandon the city 1 September 1864. The seizure of the RR was coincident with the first of two battles in Hardee's defense of Jonesboro."

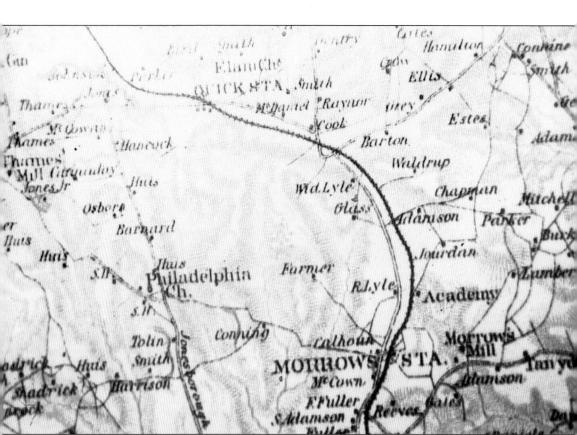

In this Civil War map, Forest Park is listed as Quick Station. Also noted is Thames Road, which is now Forest Parkway. The road traveling north and south next to the railroad is the current Jonesboro Road/Georgia Highway 54. Note that on this map, Highway 54 doglegs to the west before continuing north. The road north of the railroad tracks is today called Courtney Drive. According to this map, it appears the Jonesboro Road the Civil War soldiers marched down is today's Old Dixie Highway/Georgia Highway 41/19. (Courtesy of Jeanelle Smith Fleming.)

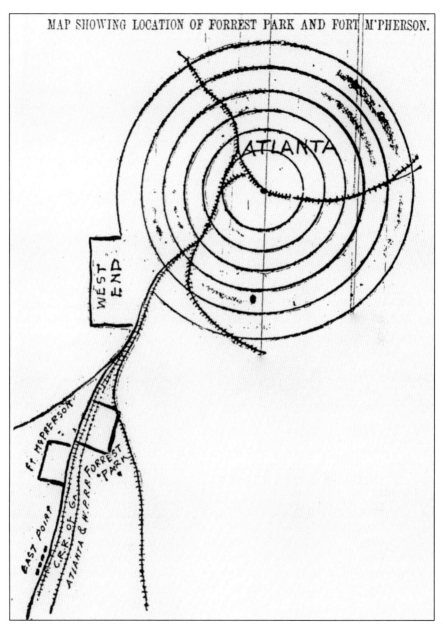

On Monday, April 25, 1898, this map was printed in the *Constitution* newspaper of Atlanta. The article, titled "Militia To Camp Around the Fort/Volunteers Will Soon Be Mobilized on Reservation/Thousands Will Be Here," refers to volunteer soldiers arriving in the area to train at Fort McPherson and states that the first volunteers to arrive will be Georgia volunteer soldiers, and as many as 3,200 may turn out. "They will have their tents in Forrest park, and will do their drill work on the drill grounds of the government reservation. . . . The Georgia volunteers will pitch their tents on one side of Forrest park. The park is a beautiful site for a reserve camp. The ground, while slightly rolling, is just right for tents, as it will carry off all superfluous water and still be level enough for the purpose desired." Forest Park and Fort McPherson are shown in very close proximity to one another on this map. The military reserve referred to as Fort McPherson is Fort Gillem today. (Courtesy of City of Forest Park.)

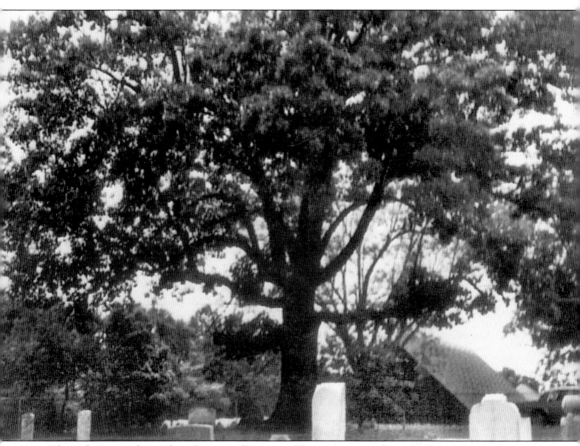

This oak tree was located on Courtney Drive near Forest Avenue, where the Forest Grove Cemetery is today. Because of storm damage, the tree was removed in 1990. Through generations of the Bartlett family, it is told that General Sherman was sitting under this tree when Caroline Bartlett came upon him. She was carrying a baby, which he asked to hold. Feeling uneasy about it, she handed the baby to him, asking him not to harm the child. Noticing she was crying, Sherman asked why. After hearing that his troops were destroying everything, taking the food and the only cow owned by the family, he ordered his troops to leave without taking or destroying anything else. On the troops' return trip north, he once again came upon Caroline waiting while the troops passed between her and her property. When Sherman recognized her, he ordered his troops to halt, allowing her to cross. (Courtesy of Debbie Bray.)

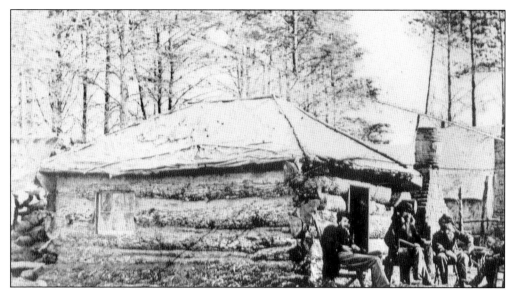

Although soldiers sometimes used existing buildings for shelter, the daughter of a soldier remembers troops sleeping in her yard and on the porch during the march south. When the war ended, her father was brought back to Atlanta, walking the rest of the distance to Forest Park. Upon arriving at the Flint River, which was below their house, he called for his wife to bring him matches, soap, washcloths, and clean clothes. He removed his clothes and burned them, took a bath to rid himself of lice, and went home. (Courtesy of Georgia Archives, Vanishing Georgia Collection, image no. clt048-84.)

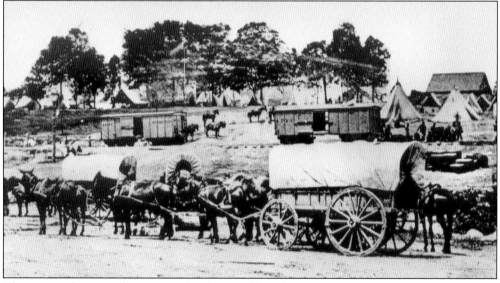

The terrain shown in this picture closely resembles Main Street and Forest Parkway, where the old depot and woodshed were located. It shows a military camp in 1864. Confederate soldiers camped along the railroad tracks in an effort to protect the supply route. Sherman's troops were ordered to burn the woodshed at Forest Park along with an order to destroy the railroad. With the railroad disabled, Southern armies would be unable to ship necessary supplies to Atlanta, further hindering the city's reconstruction efforts. (Courtesy of Georgia Archives, Vanishing Georgia Collection, image no. clt049-84.)

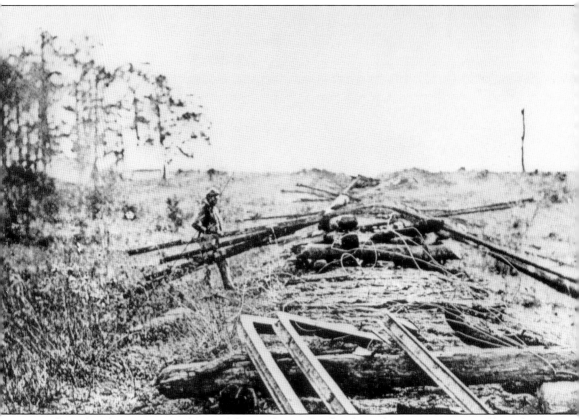

The railroad was an integral part of the Civil War. Food and supplies were transported by rail, as well as troops. During Sherman's march south, he ordered the rails to be destroyed, preventing the necessary supplies from reaching the Confederate army. Troops would pull up the rails and remove the cross ties. The rails would then be heated to a high temperature, allowing them to be bent into L and U shapes. (Courtesy of Georgia Archives, Vanishing Georgia Collection, image no. clt050-84.)

Two

CORNERSTONES OF THE COMMUNITY

Many people played important roles in the building of Forest Park. From Meredith Brown, who was in the Revolutionary War, to founding members of churches and their descendants, this city has been home to some very strong, upstanding citizens.

Life in the late 1800s and early 1900s was indeed tough. Men would go to work at sunrise and work until sunset. The majority of this work was outside and continued through all types of weather. Some of the places to work included the sawmill, blacksmith shop, cotton gin, and the farm. There were also professionals such as merchants, doctors, and lawyers.

Buildings didn't afford much comfort from the weather. Prior to the first decade of the 20th century, buildings consisted of wood and nails. If insulation was added, it was a mixture of mud and straw, sticks, or even hair.

A lot of the men worked two jobs. When they could spare some time from the farm, they would go downtown to the corner of Main and College Streets to work at one of the businesses that processed raw materials from the surrounding land. If a man grew cotton on his land, he might go work at the cotton gin to help get the cotton ready to be shipped.

Women didn't have it much easier than men. They stayed home all day and didn't "work," but they did make all the clothes by hand; prepared all the meals, including the selection and preparation of the homegrown meats and vegetables; kept the house clean (with no electric-powered tools); reared the children, which often included 10 or more; and still had the energy and the will to do it all over again the next day. They also worked in the fields when needed.

On Sundays, the family would all go to church together. The routine was to go visit relatives after church. On Saturday, the mother would spend the day baking breads and pies, cooking other foods to take with them on Sunday, and getting the Sunday clothes ready, in addition to the regular Saturday household chores (and those 10 kids).

Caroline Bartlett lived on 100 acres of land located on Courtney Drive where the Forest Park post office is today. During the Civil War, the area surrounding her home was used by soldiers. On one occasion, soldiers came to raid the smokehouse, and when she told the soldiers to help themselves, the soldiers left without taking anything, for fear it might be poisoned. (Courtesy of Debbie Bray.)

Meredith Brown (1764–1837) was the father of John Brown and was a veteran of the Revolutionary War. His grave is the second oldest in Old Elam Cemetery; only that of his son, John Brown, is older. Old Elam Church no longer exists, but the cemetery is still visible from Old Elam Church Road. (Courtesy of John Gillon.)

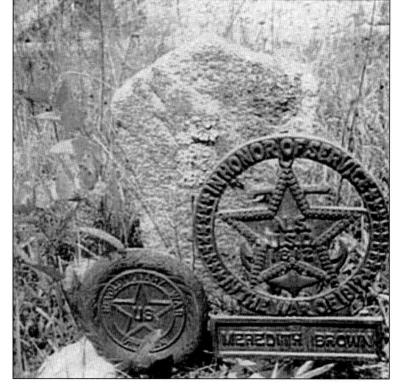

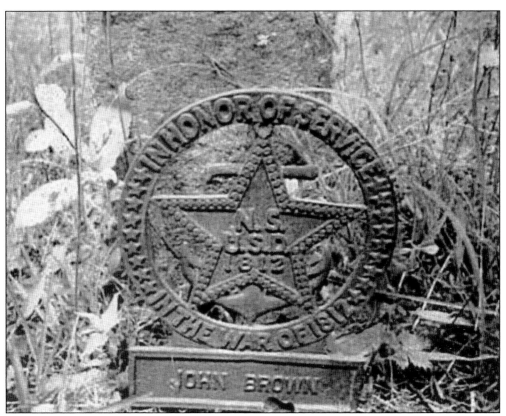

This marker is found in Old Elam Church Cemetery and denotes the burial place of John Brown (1788–1831). A veteran of the War of 1812, John's grave is the oldest-known one in the cemetery. (Courtesy of John Gillon.)

Among the earliest settlers, John Brown (1788–1831) and his father Meredith Brown (1764–1837) have the oldest-known graves in Old Elam Church Cemetery. Also buried in this cemetery are Daniel Dodson (1769–1848) and Stephen Dodson and his wife, Amy Margaret Brown Dodson. Her father was John Brown, and her grandfather was Meredith Brown. Daniel's father was Joshua Dodson, a Baptist minister believed to have served the historic Scull Shoals Church in Greene County, Georgia. Daniel was in Greene County in 1797, but by 1830, he had made his way to Forest Park. (Courtesy of John Gillon.)

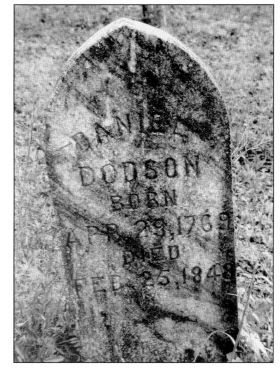

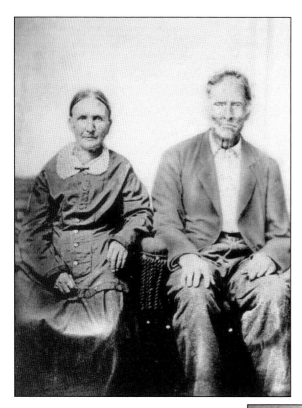

Stephen and Amy Margaret Brown Dodson are pictured in this *c.* 1885 photograph. The couple is buried in the historic Elam Primitive Baptist Church Cemetery east of Highway 54 in Forest Park. His father, Daniel Dodson; her grandfather, Meredith Brown (a veteran of the Revolutionary War); and her father, John Brown (a veteran of the War of 1812), were among the earliest settlers of the area surrounding Forest Park. (Courtesy of John Gillon.)

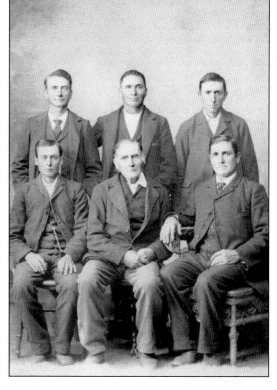

Daniel Dodson's son, Stephen, is shown with his five sons. Seated from left to right are Charles Dodson, Stephen Dodson, and B. F. Dodson. Standing from left to right are Will Dodson, Louis Daniel Dodson, and George Dodson. The men of the Dodson family were military men, with members serving in the Revolutionary War, the War of 1812, and the Civil War. (Courtesy of John Gillon.)

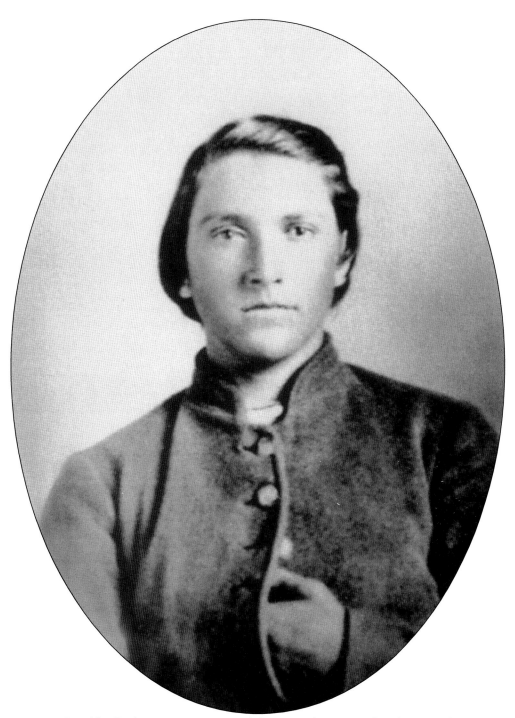

Benjamin Franklin Dodson appears in a Confederate uniform. He enlisted on March 28, 1864, in Clayton County at the age of 18. He was wounded on May 10 at Spotsylvania Courthouse, Virginia, and again on September 19 at Winchester, Virginia. He was taken prisoner on April 9, 1865, near Appomattox Courthouse and was released on June 24, 1865, at Newport News, Virginia. He walked about 600 miles to return to his Clayton County home. (Courtesy of John Gillon.)

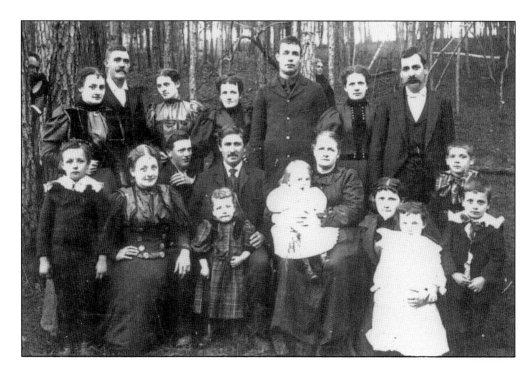

The photograph above, taken about 1898, shows Kate Dodson Ragsdale's family, the B. F. Dodson family. To the far left is O. L. Ragsdale hiding behind a tree, possibly chiding his soon-to-be wife. In 1910, the Dodson family gathered again and posed for the image below. While the individuals in the picture are not identified, family members at this time included O. L. and Kate Dodson Ragsdale, O. L. Jr., John, Ruth, and Hoke Ragsdale. Also present might have been Kate's parents, B. F. and Margaret Clark Dodson. (Courtesy of John Gillon.)

The photograph above, taken around 1910, shows Rev. B. F. Dodson and his wife, Margaret Hannah Clark Dodson. In 1918, Dodson succeeded his son-in-law Oscar L. Ragsdale as Clayton County tax commissioner upon Ragsdale's death. Reverend Dodson was also a founding member and pastor of Jones Chapel Methodist Church (later to become Jones Memorial First United Methodist Church). During his ministry, he is said to have married hundreds of couples. During the week, he was a farmer who sold milk, butter, eggs, chicken, and produce. (Above courtesy of John Gillon; right courtesy of Jones Memorial First United Methodist Church.)

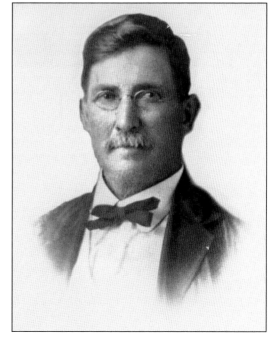

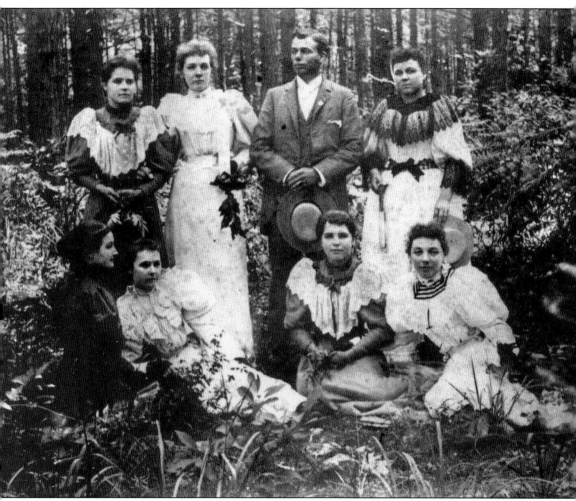

O. L. Ragsdale is seen here surrounded by women, as he must have been most of his life, for six of these ladies were his sisters, and the seventh, kneeling on the ground in the far left, is his fiancée, Kate Dodson. Pictured around 1898, some of the women can be seen with fans they used to cool themselves. (Courtesy of John Gillon.)

This photograph shows a beautiful Kate Dodson prior to her marriage to O. L. Ragsdale. She was not only known for being the wife of Mayor Ragsdale but was also a teacher in her earlier years. She also held the position of principal at Forest Park School; assisted her father in his position as tax collector of Clayton County, where she was generally viewed as de facto tax collector; and was treasurer for the City of Forest Park. (Courtesy of John Gillon.)

Oscar L. Ragsdale served as mayor of Forest Park, but the years of his term are unknown. Born in 1870, he married Kate Dodson, and they raised four children: O. L. Jr., Ruth, John, and Hoke. After serving as mayor, he became tax collector of Clayton County and moved his home to the county seat. In 1918, he died at the age of 48. (Courtesy of John Gillon.)

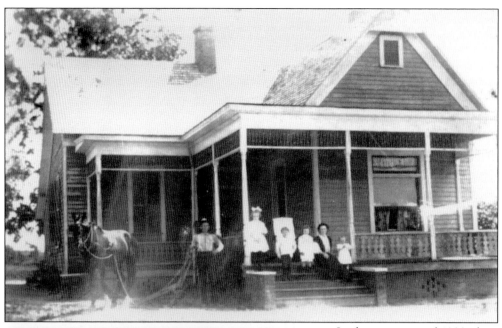

In the years around 1908, the Ragsdale family lived in this home and were raising four children. Posing from left to right are the following: O. L. Ragsdale, Ruth, O. L. Jr., John, Kate Dodson Ragsdale, and Hoke. O. L. and Kate would each become leaders of the community. He went into politics; she went into the education system. (Courtesy of John Gillon.)

After the death of her husband, O. L. Ragsdale, in 1918, Kate Dodson Ragsdale spent her many remaining years in this home on the corner of North Avenue and College Street. This home remains in the same location today and looks much the same as it did in Kate's day. (Courtesy of John Gillon.)

Andrew Jackson Wells and Amanda Evaline Almand Wells were the parents of Emmett Jackson Wells of Purity Ice Company. Pictured seated are Andrew and Amanda Wells, with Emmett and Tommie Wells standing behind them. Descendants of the Wells family think this photograph was taken around 1898, probably at the time of Emmett and Tommie's marriage. (Courtesy of John Gillon.)

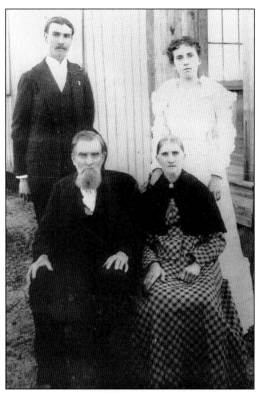

Andrew and Amanda are pictured below sitting in front of their home. Although very similar in appearance, the building in these pictures might not be the same home. Andrew lived from 1828 to 1909, and his obituary in the *Atlanta Constitution* described him as "one of the oldest residents of this section of Georgia." (Courtesy of City of Forest Park.)

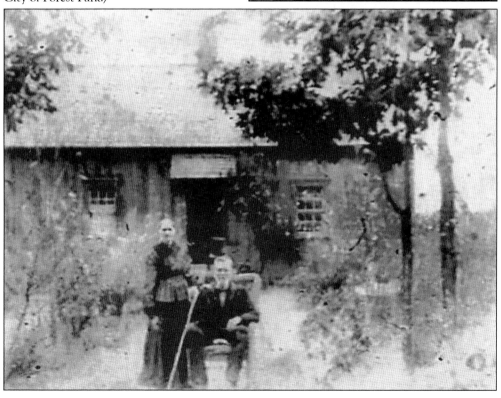

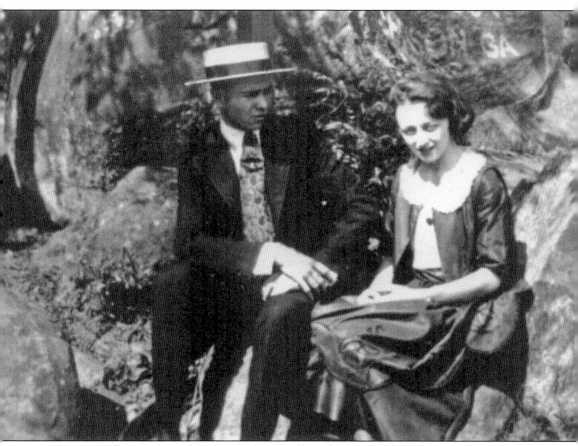

Weyman Wells, grandson of Andrew Jackson Wells and Amanda Evaline Almand Wells and the oldest son of Emmett and Tommie Wells, is seen courting Ruth Ragsdale, who would become his wife, in this c. 1923 photograph. Ruth was the daughter of Kate Dodson and O. L. Ragsdale. (Courtesy of John Gillon.)

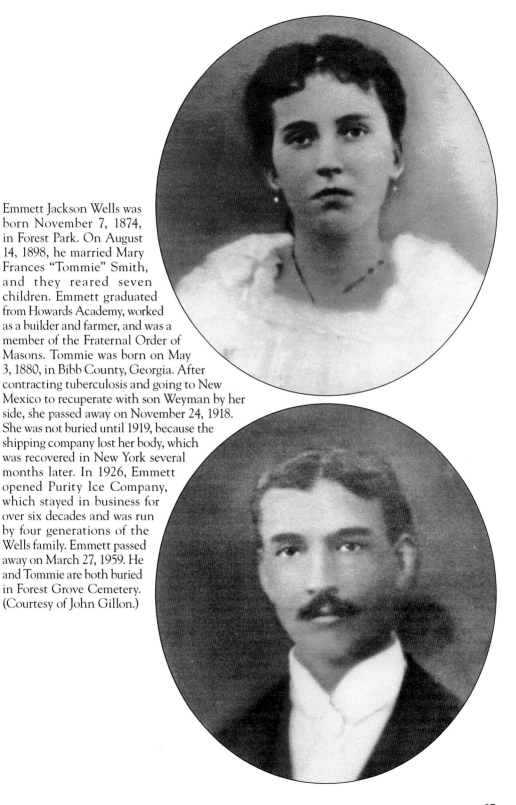

Emmett Jackson Wells was born November 7, 1874, in Forest Park. On August 14, 1898, he married Mary Frances "Tommie" Smith, and they reared seven children. Emmett graduated from Howards Academy, worked as a builder and farmer, and was a member of the Fraternal Order of Masons. Tommie was born on May 3, 1880, in Bibb County, Georgia. After contracting tuberculosis and going to New Mexico to recuperate with son Weyman by her side, she passed away on November 24, 1918. She was not buried until 1919, because the shipping company lost her body, which was recovered in New York several months later. In 1926, Emmett opened Purity Ice Company, which stayed in business for over six decades and was run by four generations of the Wells family. Emmett passed away on March 27, 1959. He and Tommie are both buried in Forest Grove Cemetery. (Courtesy of John Gillon.)

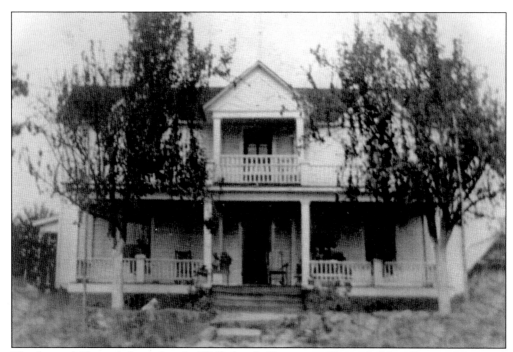

This beautiful home belonged to the Wells family. Emmett and his wife, Mary Frances "Tommie" Smith Wells, reared their children in this home, which was located on Courtney Drive behind where Emmett would later build the Purity Ice Plant. (Courtesy of John Gillon.)

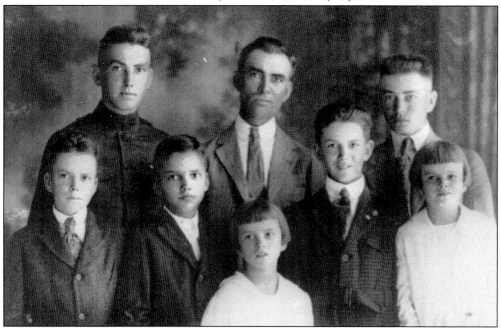

This family portrait was made shortly after the death of Emmett Wells's wife, Mary Frances "Tommie" Smith Wells. Pictured from left to right are the following: (first row) Earnest, Jack, Lorene, Lee, and Elizabeth; (second row) Martin, Emmett (father), and Weyman. (Courtesy of John Gillon.)

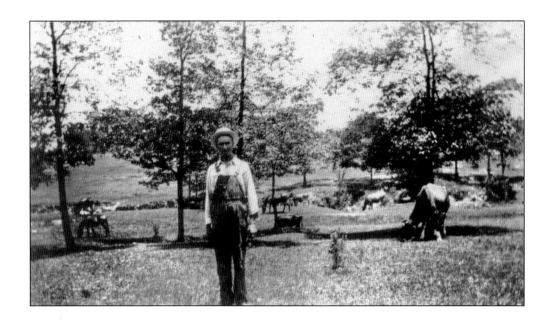

Emmett Jackson Wells is seen here on his farm in the mid-1930s. His land was on Courtney Drive, which was previously named Jonesboro Road. He graduated from Howards Academy, which was located in the vicinity of the Georgia State Farmers Market. Emmett was also a builder who operated the Purity Ice Company and was a member of the Fraternal Order of Freemasons. The photograph above was taken by granddaughter Ann Wells. In the photograph below, Ann is seen standing beside a classic automobile. (Courtesy of John Gillon.)

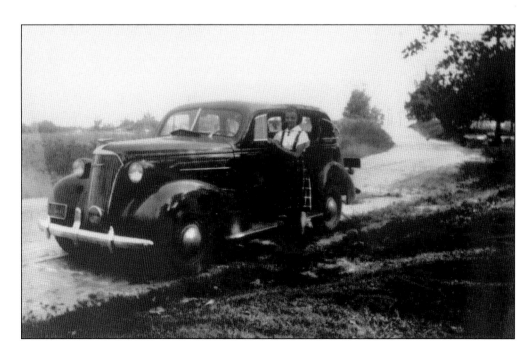

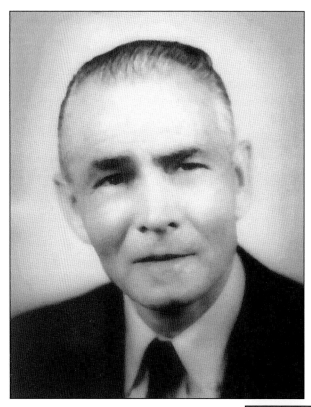

Weyman Wells (1900–1980) was the eldest son of E. J. and Tommie Smith Wells. He represented Clayton County in the statehouse from 1941 to 1942 and he served on the Forest Park School Board and the Forest Park City Council. For 63 years, he was a member of the First Baptist Church of Forest Park, and he served as church clerk for 41 years. The picture below of him wearing glasses was given to the authors by First Baptist Church of Forest Park. The portrait at left was provided by John Gillon, who is a descendant of the Wells family.

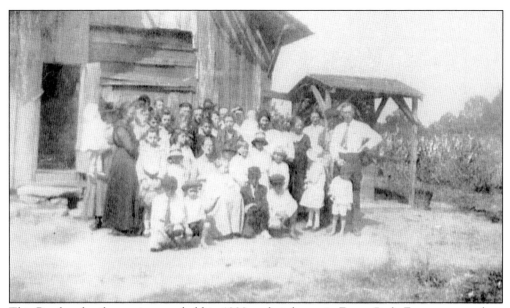

This Bartlett family reunion was held in 1908 at their home in Forest Park. Forty-one members gathered on Courtney Drive to celebrate. In 1909, the family held the reunion at Grant Park, possibly due to the fact that the family had grown in numbers to 105 members. By 1912, this number had grown to 147. (Courtesy of Debbie Bray.)

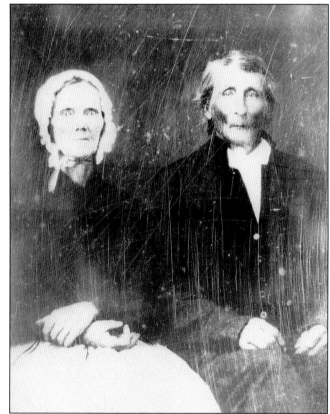

This photograph shows Martha Wood McCrory and her husband, Robert McCrory. Their daughter, Sarah Caroline, married Henry Bartholomew Bartlett, and in 1867, McCrory sold Bartlett 100 acres of land for $5 and, according to the deed, "in consideration of the natural love and affection which he has and bears to his said son-in-law." McCrory also ran McCrory Shoes, located on Main Street across from the current post office. (Courtesy of Debbie Bray.)

Henry Bartholomew Bartlett and Sarah Caroline McCrory were married on January 26, 1851, in Fayette County (now Clayton County), Georgia, by Alfred R. Smith. When first married, they lived in a small cabin, but in 1867, they were able to buy 100 acres of land from her father, Robert McCrory. This land was sold and is now the location of the post office. At this time, the Bartletts moved to Forest Avenue, where a descendant still lives. The Bartletts were faithful Christians and as such granted land to Forest Grove Baptist Church. Some of this land is used today by the church as its cemetery. (Courtesy of Debbie Bray.)

Sarah Caroline McCrory Bartlett is a good example of how strong women had to be in the mid-19th century. Standing up to General Sherman on two separate occasions and actually handing one of her children over for him to hold proved Sarah had courage that a lot of people didn't and don't possess. In addition, many women suffered the loss of several young children and infants. It was not uncommon for a woman to give birth to 11 or more children during her lifetime. Sarah survived this and more with a strong back and a pipe in her mouth. (Courtesy of Debbie Bray.)

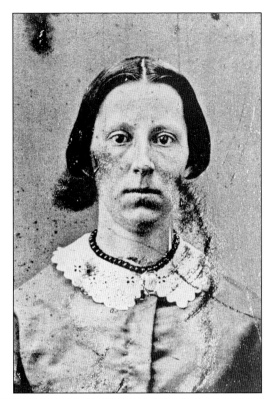

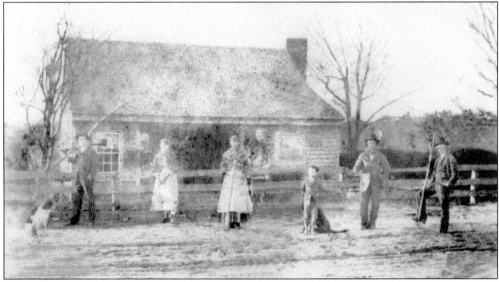

This is the home of Henry Bartholomew Bartlett and Sarah Caroline McCrory Bartlett, located on Courtney Drive. The 100 acres of land for the home was sold to Henry Bartlett by his father-in-law, Robert McCrory, in 1867 for $5 and, according to the deed, "in consideration of the natural love affection, which he has and bears to his said son-in-law." The home was built by the Bartletts 16-year-old son and was made of wood and mud. Pictured from left to right are Oscar with the axe, Missouri, Viola, Carolyn, Jessie, Henry Bartholomew, and either John or Joseph. (Courtesy of Debbie Bray.)

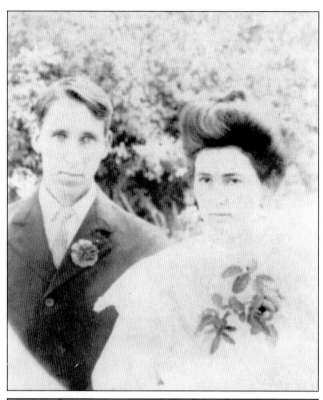

Charles Alvin Bray (1884–1972) married Daisy Dean Bartlett (1883–1970). According to family stories, the couple was married in a horse and buggy. They were active members of Flat Rock Baptist Church, where he served as Sunday school superintendent for several years. They both enjoyed going to the mountains of northern Georgia, so they bought a farm and lived there for several years before returning to Clayton County. He worked as a farmer, grocer, and a member of the government as a civil servant, from which he retired in the 1950s. He was a big fan of baseball, playing the game in his younger days and listening to it on the radio as he grew older. Daisy (pictured below) loved to garden and spent many hours taking care of her yard and flowerbeds. (Courtesy of Debbie Bray.)

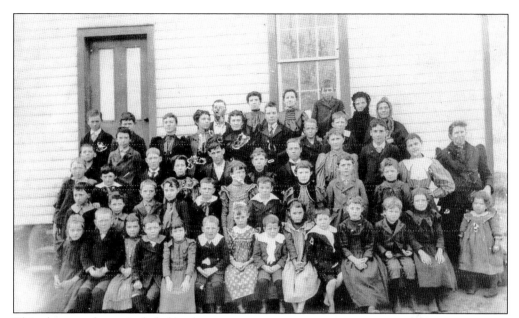

This photograph was included in the family pictures provided by Debbie Bray. Some of the names possibly represented in this picture are Bartlett, Bray, McCrory, Wootan, Bostwick, and Smith. (Courtesy of the Debbie Bray.)

Daisy Dean Bartlett was born on April 12, 1883, in the College Park/Fairburn area to Adolphus Lamar Bartlett and Sarah Eleanor Elizabeth "Lizzy" Wootan. On December 24, 1906, she married Charles Alvin Bray in Clayton County. On April 14, 1970, she passed away. She is buried at First Baptist Church, Riverdale. (Courtesy Debbie Bray.)

On December 10, 1916, Mary Ruth Bartlett married Charles Allen "Charley" Bostwick. She was born on March 16, 1896, and died on February 17, 1920. He was born on November 27, 1896, and died on March 29, 1969. Her lineage includes a sister, Nan Ethel (1894–1975), her father, Adolphus Lamar Bartlett, and her grandfather, Henry Bartholomew Bartlett. (Courtesy of Debbie Bray.)

Mary Ruth Bartlett and Charles Allen "Charley" Bostwick had one daughter, Charley Ruth Bostwick, who was born on February 10, 1920. Her mother, Mary Ruth, died seven days after the birth due to complications during childbirth. (Courtesy of Debbie Bray.)

Henry Frances "Frank" Puckett was the first mayor of Forest Park, serving from 1908 to 1909. He also served as postmaster of the Astor post office (later named Forest Park). At one time, the post office was located in a front room of his home. When not overseeing mail delivery, he worked for the railroad as a ticket agent and also pumped water into the boilers of the steam engines. (Courtesy of Judy Strickland.)

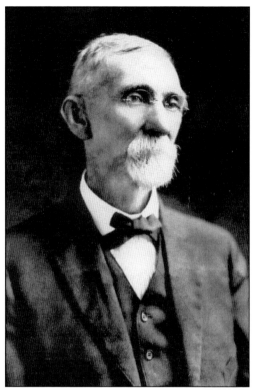

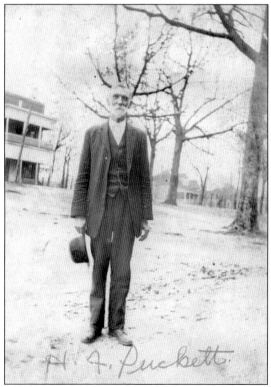

This photograph of H. F. Puckett was made on Main Street in Forest Park. In the background on the left is J. J. Evans General Store, which was the first brick building in Forest Park. Barely visible on the right is one of the city's beautiful old homes. This house was located where Davis Office Supply was more recently located, between Smith Hardware and the old C&S Bank. (Courtesy of Beverly Barton Collins.)

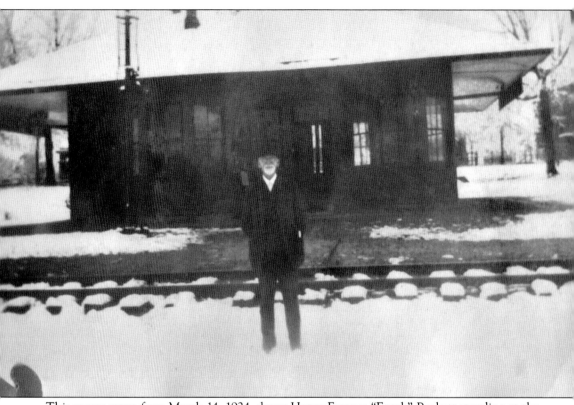

This snowy scene from March 14, 1924, shows Henry Frances "Frank" Puckett standing at the Forest Park depot. He was a former mayor of the city, postmaster, ticket agent, and he even pumped water for the railroad. (Courtesy of Beverly Barton Collins.)

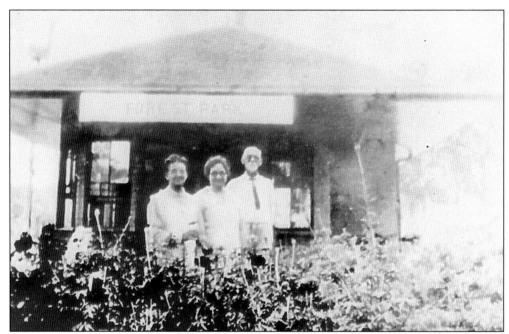

Henry Frances "Frank" Puckett is pictured with two unidentified women standing outside the ticket window of the depot. He served as ticket agent and also pumped water for the steam engines. Please notice the sign hanging above their heads. Interestingly, when this picture was taken, Forest Park was spelled with two *r*s. The city's name was so often misspelled that the city government officially changed the spelling to the current name using one *r* in 1953. Like his father, Aubrey Puckett also worked for the railroad. The gentleman in the center of this picture is Aubrey, and the other two are unidentified. (Courtesy of Beverly Barton Collins.)

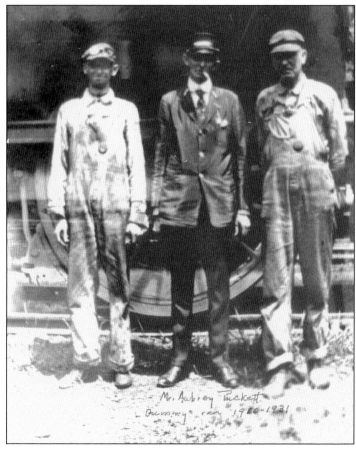

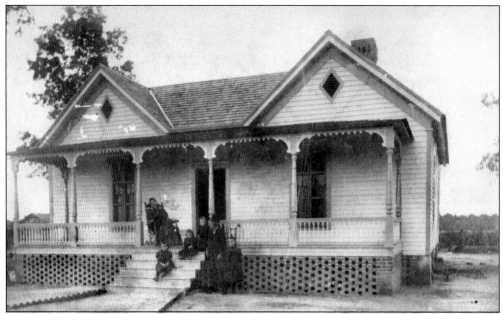

This home belonged to the Stanley family and was on Main Street east of College Street, where the Masonic Hall stands today. Owning approximately 500 acres of land, Monroe Stanley was one of the first settlers of the city. In 1903, he bought the goods from a general store that was moving and, later that same year, had the honor of introducing peanut butter to Forest Park. (Courtesy of Georgia Archives, Vanishing Georgia Collection, image no. clt075-84.)

Around 1900, this home was located at Main Street and North Lake Drive. Pictured from left to right are Aubrey Puckett, Hollis Puckett, Haskell Puckett, Molly Tanner Puckett, Henry Franklin Puckett, Comer Yancey, Forrest Yancey, Iva Lena Puckett Yancey, and William Lewis Yancey. (Courtesy Beverly Barton Collins.)

The home on this postcard belonged to William Lewis Yancey and his wife, Iva Lena Puckett Yancey. He was the eighth child of James Andrus and Rebecca Yancey and was born on May 28, 1874. Iva Lena's parents were Henry Frances "Frank" and Molly Tanner Puckett. Standing on the porch from left to right are Rebecca, Winton Lewis (Woots) Yancey, Mary Jewel Yancey Barton (holding the doll), and Iva Lena Puckett Yancey holding an infant, possibly Iva Lounette, who was born on February 12, 1909. The boy on the left with the bike is "Bate" (possibly a nickname for Forest Franklin Yancey), and the boy on the right with the bike is "Comer" (Frank "Freeney" Comer Yancey). The back of the card shows the names written by Beverly, the daughter of the girl with the doll, Jewel Barton. (Courtesy of Beverly Barton Collins.)

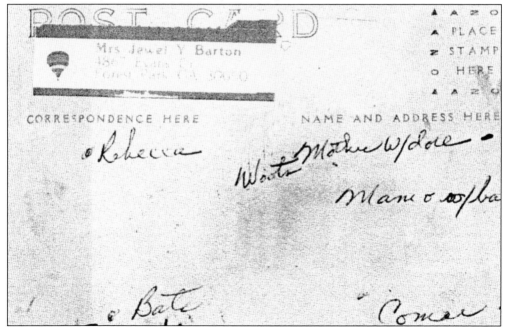

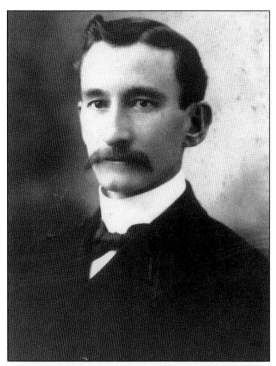

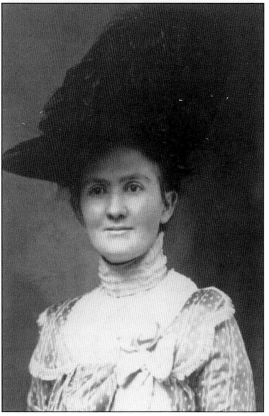

These portraits are of Dr. James Riley Barton and his wife, Lora Cosby Barton. The son of W. D. and Narcissus V. Chapman Barton, he was the first physician in Forest Park. Born in February 1867, he was the youngest of four children. His wife was born on July 8, 1876. Together they reared their seven children, Kathleen, Bernice, James Marion, Louise, Cosby, Carolyn, and Sara. The doctor and his wife came down with influenza at the same time and succumbed to the illness despite the efforts of the doctor. She passed on December 16, 1928, and he passed on December 25, 1928. (Courtesy of Beverly Barton Collins.)

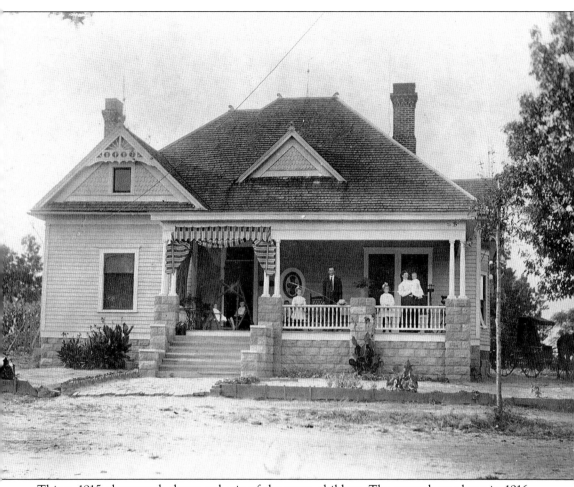

This c. 1915 photograph shows only six of the seven children. The seventh was born in 1916. The names of the adults are Dr. James Riley Barton and his wife, Lora. The children, in order from eldest to youngest, are Kathleen, Bernice, James Marion, Louise, Cosby, and Carolyn. Sara is the name of the girl born in 1916, who is not pictured. Five of the children are easily seen, but one is hidden. Look closely between the top step and the girl that is just to the right. The hint of a boy in a white shirt and dark tie can be seen between the porch banisters. (Courtesy of Beverly Barton Collins.)

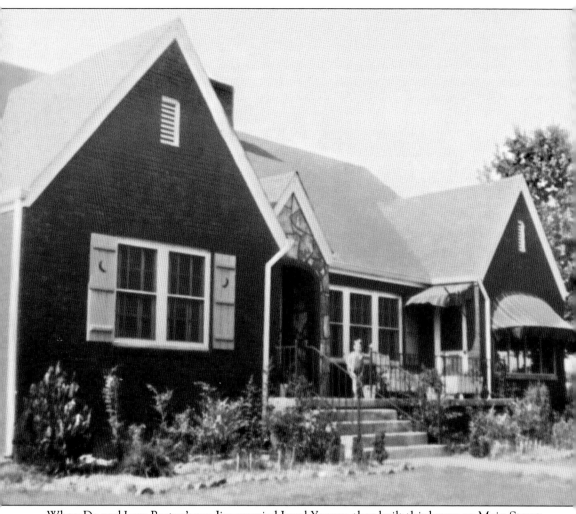

When Dr. and Lora Barton's son Jim married Jewel Yancey, they built this home on Main Street next door to Jim's parents on land belonging to Dr. Barton. Some years later, Jewel moved into a home on Evans Drive, leaving this home to her daughter, Beverly, who had the home moved from Main Street to Robin Lane (approximately one mile). She said having the house cut in two pieces and watching it being moved was one the scariest things she has ever done. The house survived and is still standing today. (Courtesy of Beverly Barton Collins.)

This grand lady was built in 1894 by Manse Waldrop, the town's 10th mayor (1941–1945). This photograph shows the home under the ownership of Pat White (January 1988–October 2007). Once remodeled to accommodate apartments, Pat renovated the house to reflect its true Southern charm. Now owned by Juanitta Johnson, the house has undergone some additional changes that reflect the character of the new owner. No matter how she is dressed, she will always have the heart of a true Southern lady. (Courtesy of Pat White, Red and Gold Florist.)

Although his years of serving as mayor are unknown, J. J. Rose was the sixth mayor of Forest Park. His farm was located on Old Dixie Highway (Highway 41/19) just south of Forest Parkway. He also had his home on Main Street. He is best known for the allotment of land he donated during the time segregation was still being enforced. The city only had two small communities of "Negroes," as some referred to African Americans at that time, with no room for the communities to grow. Rose's allotment of land provided the African Americans a larger area in which to build homes. Rose gave these citizens a permanent home to raise their families. Although the city is racially diverse, the original citizens of Rose-town and their descendants have remained in their family homes. (Courtesy of City of Forest Park.)

Charles Summerday served as mayor of Forest Park longer than any other individual. His term began in January 1968 and ended on January 4, 1982. Prior to becoming mayor, he served six years as councilman, for a total of 20 years. (Courtesy of City of Forest Park.)

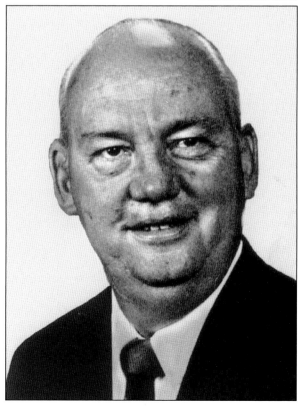

Jerry Tomasello served as mayor of Forest Park for two terms, once in the early 1980s and again in the early 1990s. A graduate of Georgia Military Academy, he is knowledgeable about any subject. Jerry and his family have contributed to this community in many ways, and the value of these contributions is too great for words. Jerry's wife, Montine, was always at his side with a smile on her face and a hand ready to help. The town lost this beautiful lady to cancer in early 2008, but the love that came from her heart will live on forever. Mayor Tomasello has always been well-known for his stories and jokes. Each one began with the phrase "did you hear the one about the ol' boy." (Courtesy of City of Forest Park.)

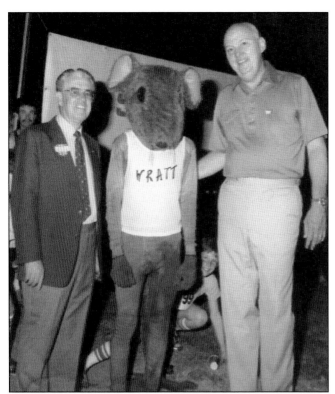

The City of Forest Park Recreation and Leisure Services has always been known for holding special events to help unite the community. This photograph was taken at a fun run called the "Wratt" Race. Shown with the mascot are former state senator Terrell Starr on the left and former mayor Jerry Tomasello on the right. (Courtesy of City of Forest Park.)

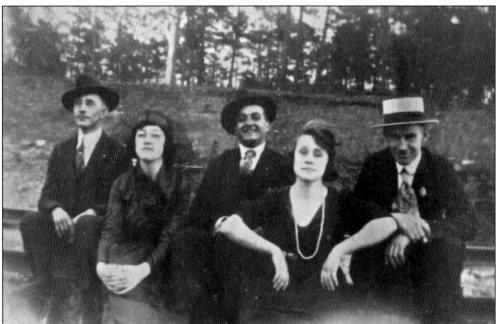

Pictured in the 1920s, five young people dressed to the nines are seen sitting on the railroad tracks. Since the passenger train was so readily available, citizens of Forest Park often rode to Atlanta for various reasons. From left to right are Pressley Conine, Eloise Chapman, Raymond Cates, Ruth Burks, and Jess Swinney. (Courtesy Beverly Barton Collins.)

These folks were some of the early residents of Forest Park and include Frank Puckett (shown wearing a hat) and his wife standing in front of him in the center of the picture. The train depot can be seen in the background, and the rubble on the side of the group is the remnants of the water tower, which resembled a castle turret when it was standing. (Courtesy of Beverly Barton Collins.)

These four ladies are fishing on Lake Mirror, which was a popular gathering spot for kids from Forest Park and surrounding towns. Tom Lee owned the lake, which was located between Old Dixie Highway (Highway 41/19) and Clark Howell Highway, in the vicinity of the Georgia State Farmers Market. Families could always swim and have picnics at the lake, but intoxicants were restricted, and Tom was tough. (Courtesy of Miriam Farmer, who is seated in the light-colored dress.)

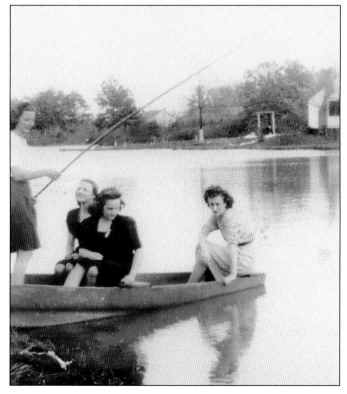

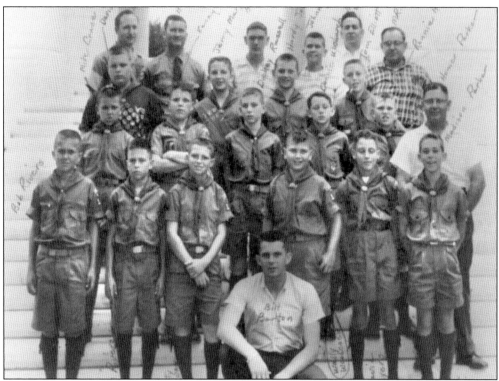

Shown during a trip in June 1958, this group includes the following, from left to right: (first row) Bob Rivers, Bill Rivers, Marty Calloway, Bill Barton (kneeling in front), Wally Woodcock, David Myers, and Madison Parker; (second row) Mike Cruce, Kenny Bryson, Dickey Russell, Donnie Upchurch, Ronnie Harrell, and Homer Parker; (third row) David Elliott, Jerry Murphy, Hardy Johnson, and Tom Elliott; (fourth row) Ed Brown, H. B. Cruce, Harry Fowler, Johnny Cruce, Harold Upchurch, and M. R. Sutton. (Courtesy of the First Baptist Church of Forest Park.)

The City of Forest Park Recreation and Leisure Services Department often holds events for the citizens. This photograph shows one of these events. It was a greased pig contest, when a person would run after the pig and try to catch it. At one of the events, there was no fenced area for the contest, so pigs were running through the streets and into yards. A fence was quickly erected. (Courtesy of City of Forest Park.)

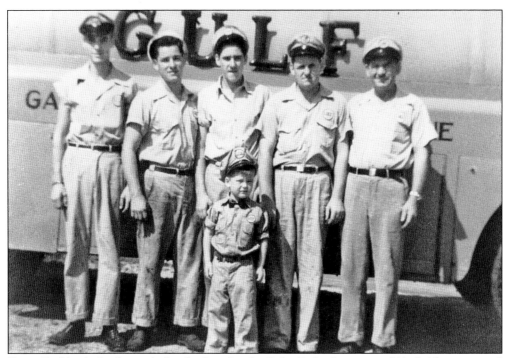

Forest Park's who's who includes the Lee family. Colie Rufus Lee, one of 11 children, married Velma Juanita Haynie, and together they reared four children. Colie owned and operated a local Gulf station with family members. Shown here from left to right are Bobby Bray, Gene Lee, Jere Lee, Bill Lee, and Colie. Standing front and center is Randy Bowlden, son of Ralph and Nita Bowlden. (Courtesy of Debbie Bray.)

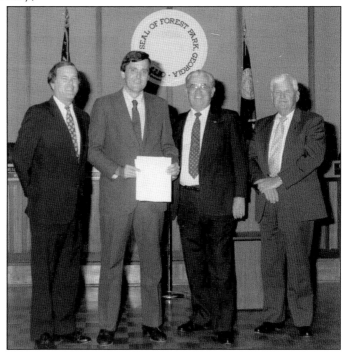

Taken in the late 1980s, this picture shows four men who grew up in Forest Park and made names for themselves in the political arena. From left to right are former state representative Jimmy Benefield, former mayor Matt Simmons, former state senator Terrell Starr, and former state representative Bill Lee. (Courtesy of City of Forest Park.)

As of the date of this book's publication, Forest Park is proud to have Nellie McKown as its eldest living citizen. Born on October 20, 1906, "Miss Nellie" attended Georgia State College for Women in Milledgeville. Upon graduation, she taught third, fourth, sixth, and seventh grades at Joseph Humphries Grammar in Atlanta. She opened Blair Village Grammar School in 1952 and was a teaching principal in the school. She was an educator until her retirement in 1967. She and her husband, Marion, were married for 63 years. When they first began dating, women teachers were not allowed to marry, so they dated for 13 years until the ban was lifted. She is a member of the First Baptist Church of Forest Park, has taught Sunday school, and has served as a church pianist. Nellie and her sister Ethel are at left. (Courtesy of Nellie McKown.)

Three

WE GATHER TOGETHER

Spirituality and faith have always played a major role in the lives of Forest Park's citizens. Having a place to gather and share a common bond was the difference between surviving and not surviving. The church family would unite anytime an emergency arose, whether it be a building demolished by a windstorm or the birth of a child.

The early churches in the area were Philadelphia Presbyterian Church, which had its beginnings at Tanners Baptist Church in Riverdale; Jones Memorial First United Methodist Church, formerly Jones Chapel; Forest Primitive Baptist Church; and First Baptist Church of Forest Park, which was originally named Forest Grove Baptist Church. These four churches all began in the mid- to late 1800s and are still spreading the gospel today.

At times, churches will divide for one reason or another. One such incident occurred at Forest Grove Baptist Church, when a new preacher came in and preached a sermon on foot washing. According to W. I. Bartlett in *As I Remember*, "Some people favored foot washing and some did not. Some wanted to wash their own feet and some thought they should wash one another's feet. There was a great stew or fuss in the church. One man got his knife out of his pocket and opened it, and one good old brother told him to close his knife because no one was afraid of it. Finally, the 'Wet Foot' Baptist walked out and the 'Dry Foot' Baptist put new locks on the doors." Forest Primitive Baptist Church was formed by the members who left Forest Grove Baptist Church.

Rifts still occur in churches today over the color of carpet, the gender of minister, or the music sung by the choir. Not every member of a church can be fulfilled by his or her church 100 percent of the time, and not every reason for division of a church seems valid, but the foot washing belief is definitely interesting.

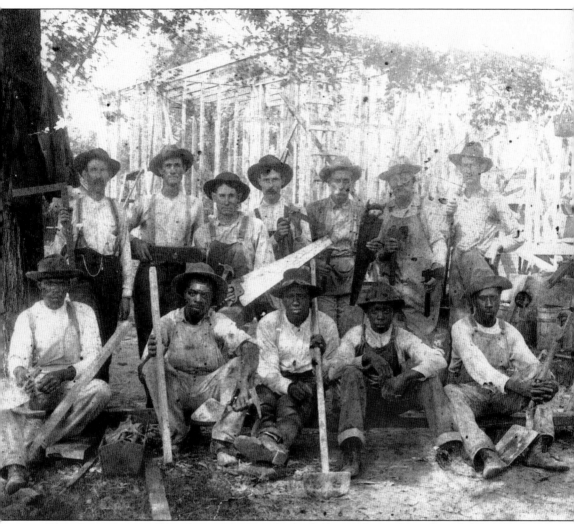

This shot, taken in 1874, shows the men who built Forest Grove Church and the tools they worked with. The following excerpt was taken from notes obtained from the First Baptist Church of Forest Park, recorded on March 14, 1874. "We your building committy beg leave to report to the best of our skill to prossicute the work assigned to us. the results of which are as follows: All the expenses have been met and settled by giving our _____$90.00." The report goes on to list the materials used and the expenses, including $329.25 for lumber, $31.50 for nails, and $12 for lime and hair. The total cost was $1,012.75. (Courtesy of Debbie Bray.)

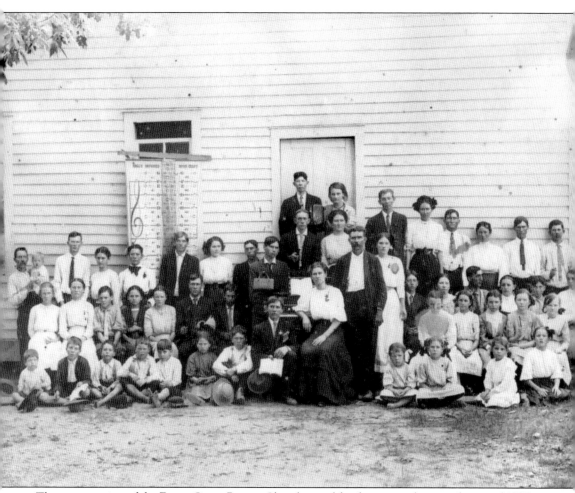

The congregation of the Forest Grove Baptist Church posed for this group photograph around 1895 during an all-day singing and dinner on the grounds. The church was located first on the corner of Watts Road and Jonesboro Road (Highway 54), then moved to the corner of Courtney Drive and Forest Avenue, and finally moved to Main Street, where the current church still stands, and the name changed to the First Baptist Church of Forest Park. (Courtesy of Herschel Smith.)

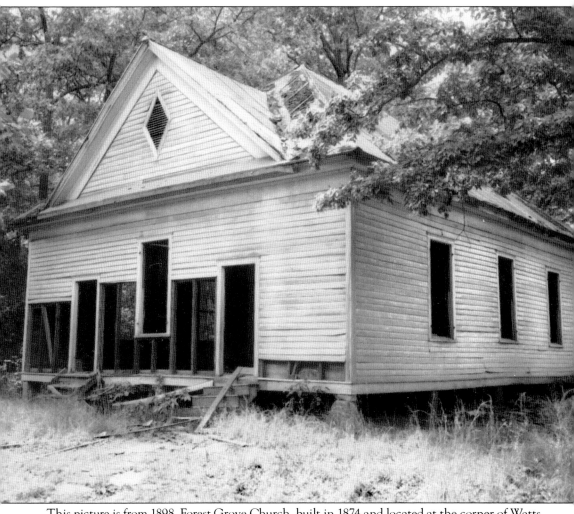

This picture is from 1898. Forest Grove Church, built in 1874 and located at the corner of Watts Road and Highway 54/Jonesboro Road, is being carefully taken apart. The building was moved to a new location on the corner of Forest Avenue and Courtney Drive. It was later moved to the corner of Main Street and Hendrix Drive, and the name was changed to the First Baptist Church of Forest Park. Another Baptist church had started, and Forest Grove wanted everyone to know they were the first Baptists in Forest Park. The 4-inch-by-4-inch negatives are the property of the City of Forest Park. (Courtesy of City of Forest Park.)

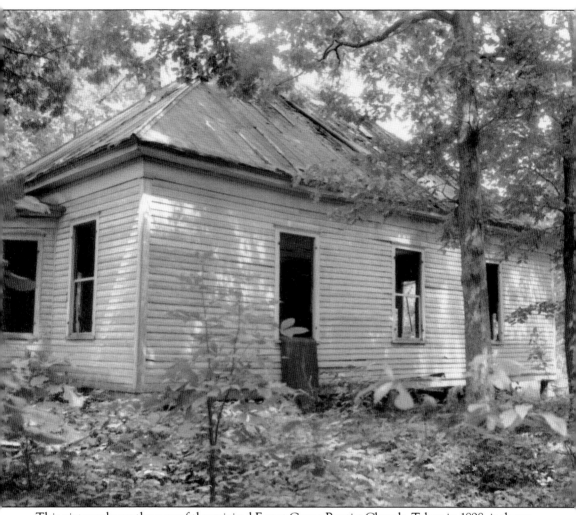

This picture shows the rear of the original Forest Grove Baptist Church. Taken in 1898, it shows a great shot of construction during that era. (Courtesy of City of Forest Park.)

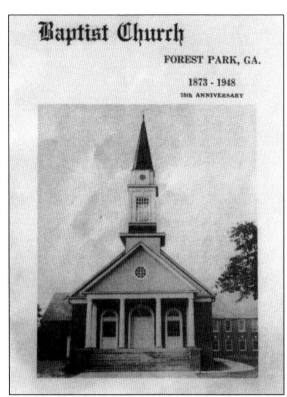

Baptist Church

FOREST PARK, GA.

1873 - 1948

75th ANNIVERSARY

With only 20 members, the Forest Grove Baptist Church was formed from Tanners Baptist Church. The first house of worship seated 300 people and was a frame structure built in 1874. Starting on October 1, 1939, the church became a full-time service church. Prior to this, the church had worship services only two Sundays each month. This church picture is from the 75th anniversary in 1948. The group picture was taken on March 5, 1974, when a proclamation honoring Clayton County's late poet laureate Barbara Fowler Gaultney was issued by the Clayton County commissioners. Seated from left to right are Roger Miller, Jack Wells, and P. K. Dixon. The members standing are, from left to right, Nellie McKown, Exor Waldrop, and Sara Mobley. Gaultney wrote a hymn that can be found in the *Baptist Hymnal*. (Courtesy of the First Baptist Church of Forest Park.)

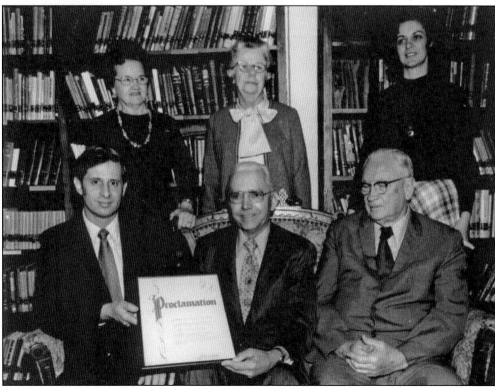

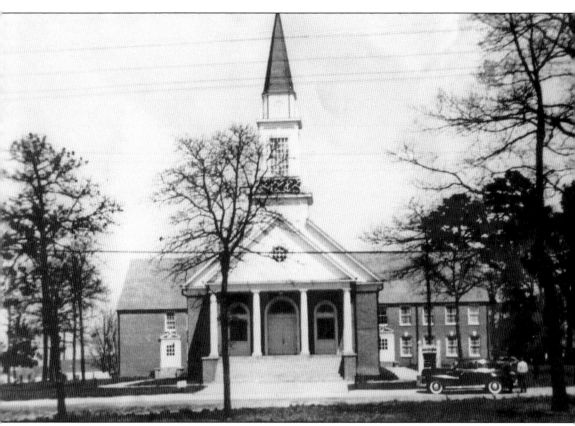

The First Baptist Church of Forest Park, formerly known as Forest Grove Church, changed its name in 1954. Between 1954 and 1957, the church purchased lots adjacent to the church property for additional grounds. An educational wing was also completed during this period. (Courtesy of the First Baptist Church of Forest Park.)

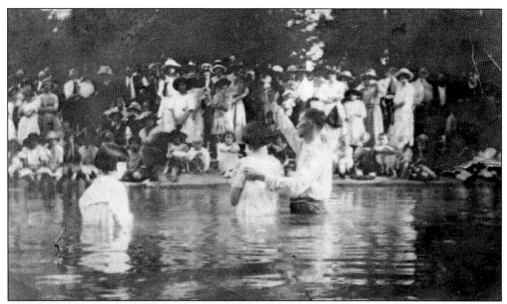

In the Baptist Church, it is believed that in order to cleanse the body and sanctify the soul, the rite of baptism must be administered by immersion. These photographs show baptismal ceremonies being held in a small pond in the Rock Cut Road/Simpson Road area (above) and at Lake Murray, which lies near Conley and Thurmond Roads (left). The land surrounding the pond location remains untouched, but the waters feeding the pond have all but dried up. Lake Murray is still enjoyed today by residents living in the area. These waters were shared by all people of all faiths and all ethnicities. (Courtesy of Jeanelle Smith Fleming.)

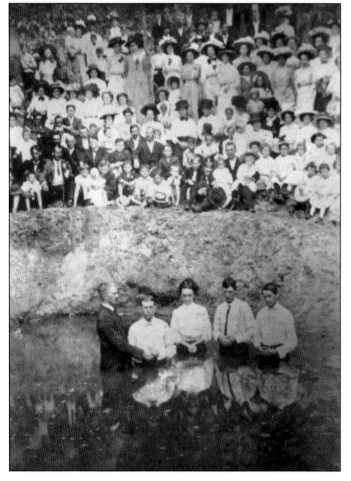

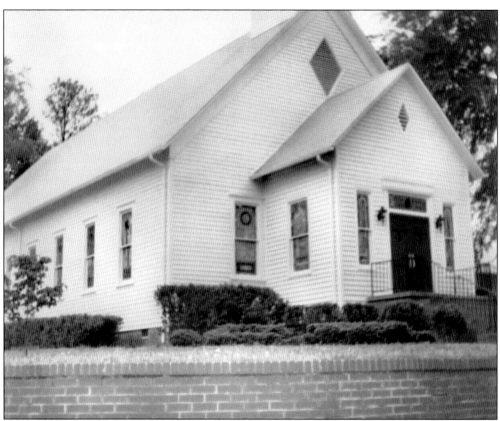

Philadelphia Presbyterian Church started in 1825, though no records exist to document the first five years of church meetings. In 1831, record keeping began in earnest, with the events of 1830 recorded from memory. The church's history continued as the Civil War broke out. General Sherman's army marched through on its way to Savannah, leaving pain and destruction in its path. Many members volunteered and fought valiantly at the front. Nine members of Philadelphia Presbyterian Church lost their lives in battle or in prison camps. At right is a member of the Huie family, Eleanor Huie. The Huies are among the oldest families in Forest Park and were one of the founding families of Philadelphia Presbyterian. Their family cemetery, located on Ash Street, is the oldest cemetery in the city. (Above courtesy of Philadelphia Presbyterian Church; right courtesy of Georgia Archives, Vanishing Georgia Collection, image no. clt042-84.)

61

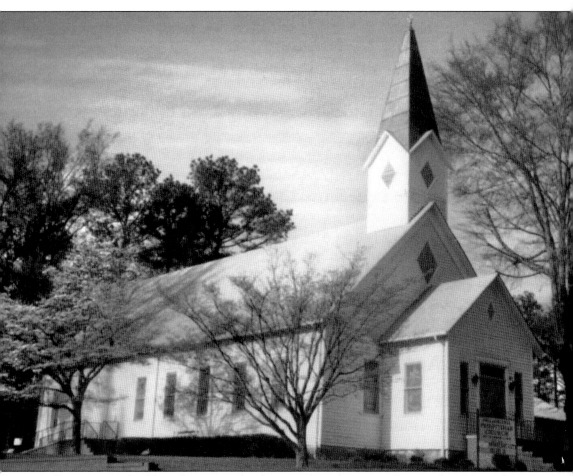

Three separate buildings have served as houses of worship, according to the 175-year history covered in *Philadelphia Presbyterian Church 1825–2000*. The first was built shortly after the 1825 organization of the church and was located across the road from the present-day building. The second building was erected in either 1858 or 1859. The third and present building was constructed in 1895. Interestingly, almost all the construction of the houses of worship was performed by members of the church. (Courtesy of Philadelphia Presbyterian Church.)

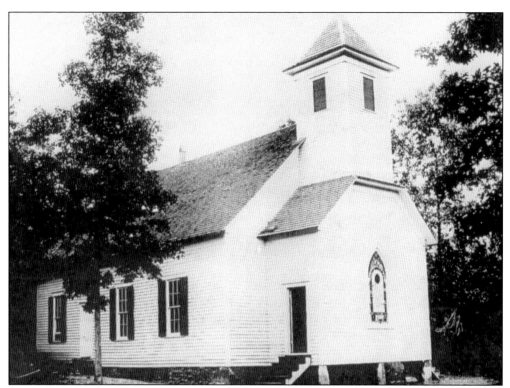

Around the year 1895, a traveling prayer meeting was started out of Mount Zion Methodist Church on Stewart Avenue in Atlanta. As the prayer meeting traveled from house to house, interest and crowds grew so much that it was decided a church building was needed. In 1896, land was donated by Brother John Jones, and the people gave liberally. In the spring of 1897, Jones Chapel was completed, and a dedication service was held. On Easter Sunday 1949, ground was broken for a church school building. By 1952, the congregation had grown so that the sanctuary was too small and the taxes were overwhelming. With plans adopted, the educational building expanded, and a new sanctuary completed, October 4, 1953, marked the first church service in the new facilities. Having outgrown this building, the church moved in 1975 to Phillips Drive in Lake City into a new facility with a sanctuary able to seat 750 people. It is now known as Jones Memorial First United Methodist Church. (Courtesy of Jones Memorial First United Methodist Church.)

The idea for Forest Primitive Baptist Church, located on Main Street in Forest Park, started with the Speir family. The date of the church's organization is unknown, but in 1898, the building was blown over onto the road by a windstorm. Members quickly gathered and built the church back on its original location. The present church is located slightly east of the original location. (Courtesy of City of Forest Park.)

Four

WALKING UPHILL
BOTH WAYS

Education in Forest Park was not available to every student. The first schools in the area were private, and the majority of the families could not afford to send their children to these schools. Besides the cost, the children were needed on the farms to help cultivate the crops in the fall and prepare and plant the fields in the spring.

The first school in the area was sponsored by the Forest Grove Baptist Church. This allowed area children to attend school at no cost to them. It was still difficult for some because of the work at home.

Originally located on the corner of Watts Road and Jonesboro Road (Highway 54), Forest Grove School was a 20-foot-by-30-foot wooden structure with a door at one end and a fireplace at the other. In the spring of 1898, the school building was moved to the corner of Forest Avenue and Courtney Drive.

In the fall of 1898, a new school was built facing what is today known as Finley Drive. At the time, Finley Drive was a dirt path made with a two-horse plow. From this point on, there has always been a school on this corner. With names such as Forest High, Central Elementary School, Forest Park High, Forest Park Junior High, and today's Forest Park Middle School, a lot of minds have been nurtured on this land. Many have returned to this place to teach new generations how to fulfill their dreams.

Today Forest Park Senior High School sits proudly on a hill overlooking Phillips Drive. Nicknamed the "Pride of Forest Park," the Forest Park Panthers have educated some great humans. Although too many to name here, the city is proud of its children and what they have accomplished and hope that today's children follow in their footsteps.

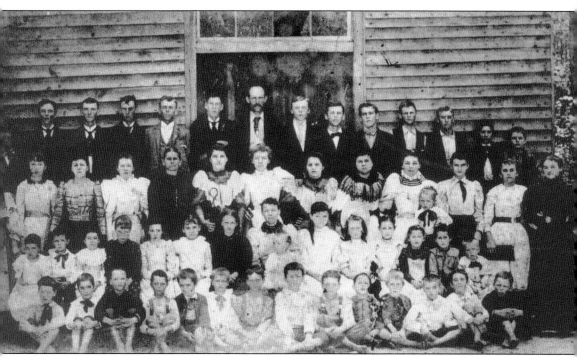

O. L. Ragsdale was born in 1870. This school picture may have been taken around 1890. It shows O. L. standing in the back row, fifth from left. The only person identified is the teacher standing on the far right wearing the dark dress. Her name is Kate Dodson, and she would soon become Mrs. O. L. Ragsdale. (Courtesy of John Gillon.)

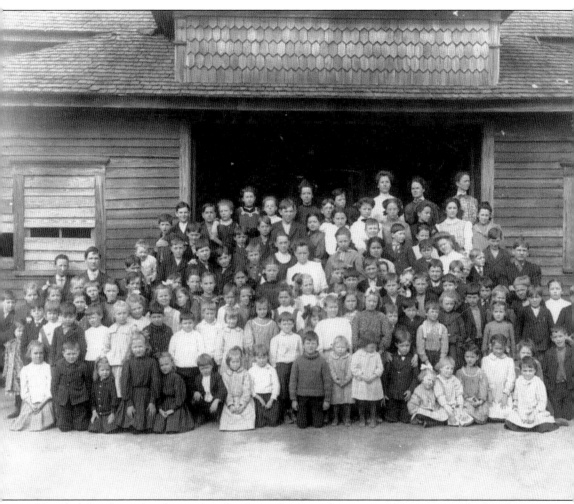

Herschel Smith was kind enough to let the authors use this picture showing an early class from the first school in Forest Park. The school was sponsored by the Forest Grove Baptist Church, so the school shared the name of Forest Grove. It was located at Watts Road and Jonesboro Road. The exact date of this image is unknown, but some of these students have been identified and include the following: Ruth Burks Foster, Grace B. Lane, K. Barton, Bernice B., James B., Lillie Mae Bartlett, Joe Smith, Mamie Yancey, Bealer Yancey, Myrtice Burks, Rosa Daniel, Daisy Lanzenby, Harold Smith, Jewel Sims?, Celofus Burks, Calvin Walden, Raymond Cates, Verl Willingham, Mamie Walker (Yancey, this name was listed twice on the back of the picture), Ethelyn Smith Christian, Herman Yancey, Elsie Burks Dodd, John Parker, Thomas Logan Harrison, Susan Walden Puckett, J. W. Burks, Lula Waldrop, Erma George (teacher), Maude George (teacher), and Lena? Wells. (Courtesy of Herschel Smith.)

These kids are enjoying a game in front of Forest Park High School. This school was located on College Street and was used from 1912 to the 1930s. Today there are tennis courts on the property, and Finley Drive borders the property to the north, which would be on the right side of this picture. When this picture was made, Finley Drive did not exist. (Courtesy of Jeanelle Smith Fleming.)

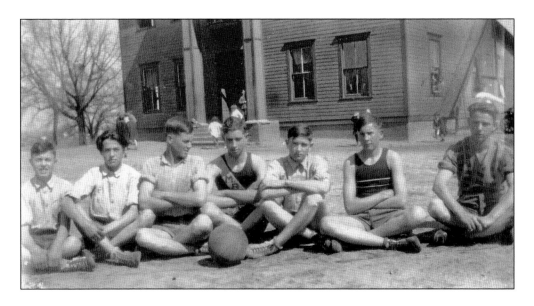

These two photographs show the basketball teams of Forest Park High in the first decade of the 20th century. During this time, basketball was the only organized sport offered in the school. The boys are, from left to right, Hugh Mabry, Milton Burks, Frank McKown, William Grant, Marion McKown, Dixon Martin, and J. D. Burks. Shown in the boys and girls combined photograph below are the following, from left to right: (first row) Elizabeth Wells, Nannie Bartlett, Louise Bartlett, Frances Owens, and Lorene Wells; (second row) Marion McKown, J. D. Burks, Milton Burks, William Grant, Dixon Martin, Frank McKown, and Hugh Mabry. (Above courtesy of Nellie McKown; below courtesy of the First Baptist Church of Forest Park.)

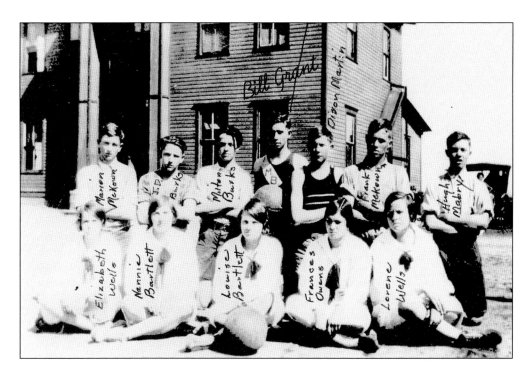

The number of students graduating in the early part of the 1900s seems unbelievably small by today's standards. With only 500 citizens, many of whom did not finish school, the seven graduates in this picture were among the lucky ones. In this c. 1932 photograph, the only individual to be identified is Lillie Mae McKown, born in 1915. She is the first graduate on the left. (Courtesy of Nellie McKown.)

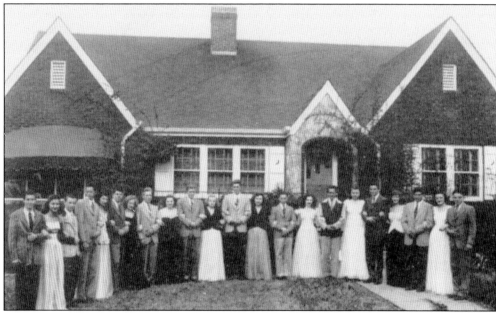

In their yearbook, the senior class president of 1947, Dorothy Chapman, said, "Too soon we 30 seniors of 1947 must separate. Eleven of us entered school together one memorable morning in September 1936. Coming all the way from the first grade to the eleventh grade together are Iris Blackwell, Betty Jefferies, Molly Lee, Louise Coogler, Pauline Laney, Fred Green, Milton Yancey, Harry Phillips, Tyndol Barnette, Marion Smith, and Dorothy Chapman." The senior class of 1947 poses in front of the Barton Home on Main Street. Included in this picture are Herman Brown, Gloria Morgan, Frank Wheeler, Louise Coogler, Charles Sargent, Jeanette Stone, James Chambers, Sara Humphries, Harry Phillips, Barbara Smith, Billy Smith, Dorothy Chapman, Joe Pollard, Molly Lee, Gene Smith, Joyce Whitfield, Fred Green, Betty Jeffries, Milton Yancey, Marion Smith, Iris Blackwell, and Tyndol Barnette. (Courtesy Beverly Barton Collins.)

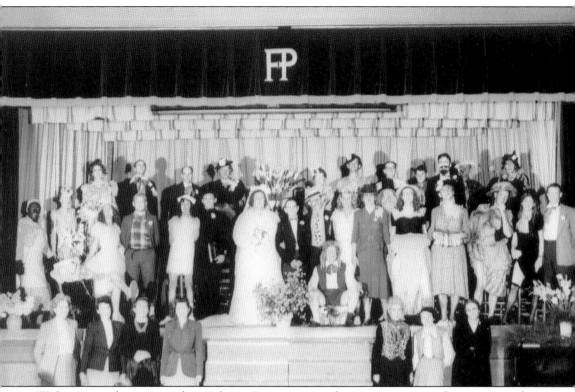

With props and costumes, these "clowns," as a cast member put it, put on a three-act comedy called *A Womanless Wedding*. Knowing these people, it was guaranteed to be a night full of humorous moments. Proceeds from the event went towards building the Forest Park High School gymnasium, still in use by Forest Park Middle School. Some of the participants included Aubrey Starr as the bride, N. T. Dennis as the groom, Malcolm Huie, William Haynie, H. H. "Nig" Estes, B. C. Haynie, Bill Lee, Tommy Thomas, Joy Huie, ? Witherington, L. T. Allison, Lowell S. Terrell, Frank Lee, Grady Granade, Lynn Wells, Grady Lindsey, Eleanor Terrell, Jewel Barton, and Mrs. Grady Lindsey. The event was standing-room only and is still being talked about. (Courtesy of Georgia Archives, Vanishing Georgia Collection, image no. clt057-84.)

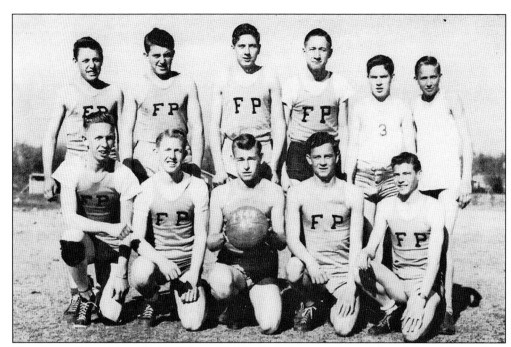

The picture above shows the 1945 Forest Park basketball team. Pictured from left to right are (first row) first team members William Mills, William "Gus" Haynie (captain), Loren Cheaves, Buster Finley, and Bobby Joe Babb; (second row) second team Frank Alford, Parker Brown, Doug Dunn, Richard Haynie, Hoyt Trammell, and Lynn Wells. Haynie's dad, B. C. Haynie, was influential in having the gymnasium built. One day, he announced that Gus, along with some others, would lay the blocks for the gym. When he asked his "pop" how they were going to build it, B. C. simply said, "we're gonna lay the blocks one at a time." And that's the way it was done. Gus said, "We didn't know any better. We used an old-style concrete block, an 8-inch block that weighed 40 pounds and a 12-inch block that weighed 70 pounds." John Lee and William Mills helped Gus build the gym. (Courtesy of William and Doris Haynie.)

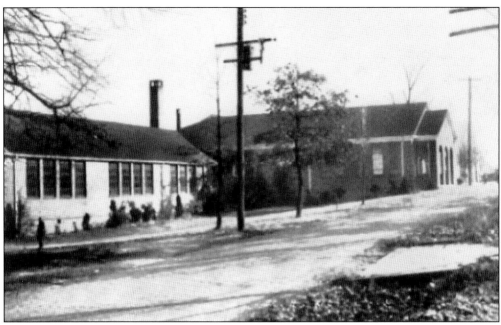

These two pictures show Central Elementary School, which was located at the corner of College Street and Finley Drive. The buildings above faced College Street, and below, Central Elementary School faced Finley Drive. This lot originally belonged to Monroe Stanley. He saw that Forest Park needed a school centrally located, so he provided the land for the school. The Forest Grove School moved from Courtney Drive, where the water tanks are now, to Stanley's land. This property still has a school building on it today. It has served as Forest Grove School (all grades attended), Forest Park High, Central Elementary, and Forest Park Junior High, and today it is Forest Park Middle School. (Courtesy of Beverly Barton Collins.)

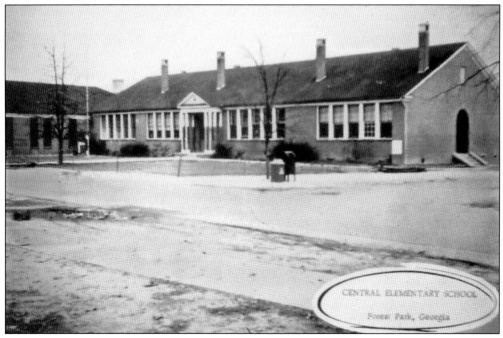

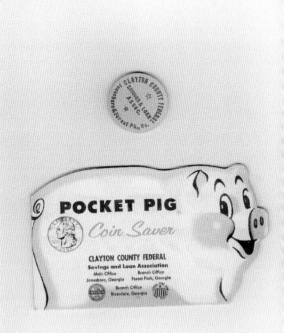

Clayton County Federal Savings and Loan Association was located on Main Street. The building it inhabited was built by J. J. Evans and was the first brick building in Forest Park. The bank gave these pocket pigs to students in the area to help them learn how to save money. (Courtesy of Glenn Worley.)

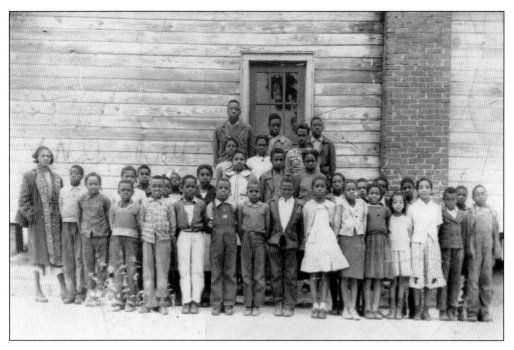

According to Mattie Hartsfield, of the three African American communities in Forest Park, only Rose-town had a school and a church. Forest Chapel School, also referred to as Forest Park Junior High, taught students in first through ninth grades. Jonnie Mae Brown was one of the principals Mattie recalled, and Susie Perkins was the last principal of Forest Chapel School. The dates of these pictures are unknown. (Courtesy of Mattie Hartsfield.)

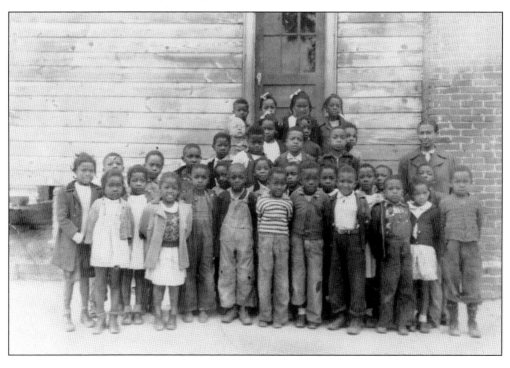

The top photograph shows Kiddie Town Kindergarten, a home away from home for many young people. During class time, they were taught how to spell their names and what words started with each letter of the alphabet. After juice, cookies, and a nap, it was time to go to the day care area and play until it was time to go home. Francis Youmans was the owner of the school, which was equipped with two classrooms (Mrs. Welch's 1962 class is shown below), a kitchen, a dining area, play and nap areas in the day care, and a playground that, to the little people who attended, looked huge and full of adventure. (Courtesy of City of Forest Park.)

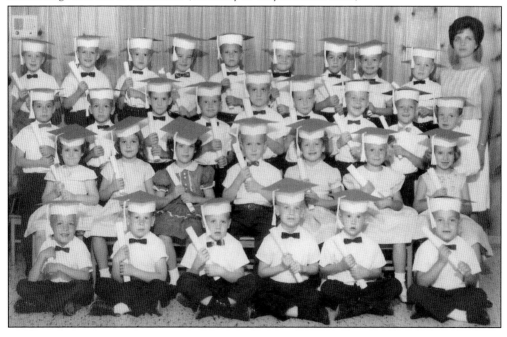

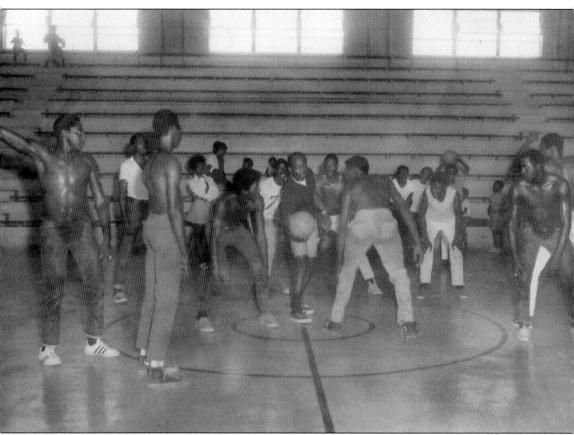

This photograph was taken in the gymnasium at Fountain High School and in the early to mid-1960s. This was the last decade Fountain High School was in existence. Desegregation began in Forest Park in 1968 when Fountain High School and Forest Park Senior High School began consolidation. By 1970, the process was complete. (Courtesy of City of Forest Park.)

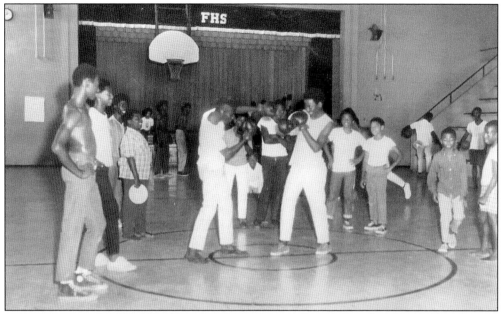

Originally called Forest Chapel School, the name was changed to honor William Alfred Fountain Jr., who is referred to by the school's Web site as "a great educator, statesman, theologian, philanthropist, and a world leader, in that he served several Episcopal Dioceses from America to Africa with pride, distinction, and honor." Perched on the highest point in Clayton County, W. A. Fountain School covers 22 acres. Although keeping the W. A. Fountain name, the school has undergone a number of changes. In 1968, consolidation efforts between the school and Forest Park Senior High School began, and by 1970, Forest Park was the only high school in the city. Fountain then became a junior high school, teaching only seventh grade. In 1989, it changed to an elementary school, housing grades from pre-kindergarten through fifth. It remains so at the present time. These photographs, taken in the gym at Fountain High School, show students involved in boxing and showing off rope-climbing skills. (Courtesy of City of Forest Park.)

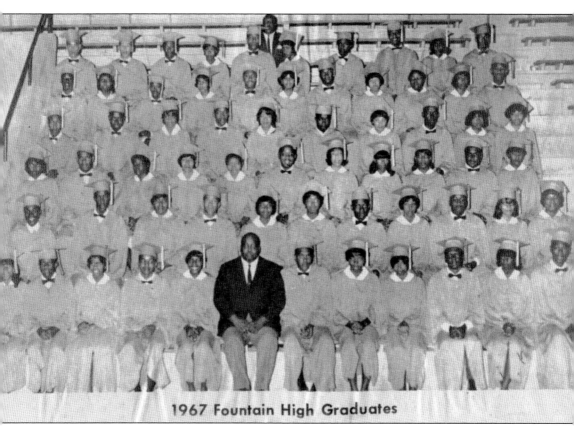

1967 Fountain High Graduates

These students proudly represent the final graduating class of Fountain High. Students after this attended Forest Park Senior High as part of desegregation in Forest Park. (Courtesy of Mattie Hartsfield.)

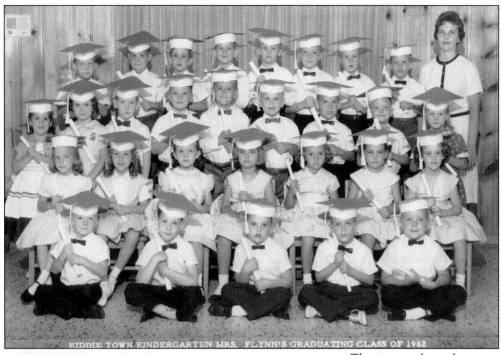

KIDDIE TOWN KINDERGARTEN MRS. FLYNN'S GRADUATING CLASS OF 1962

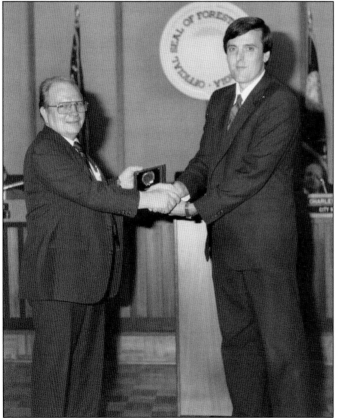

The picture above shows Mrs. Flynn's 1962 Kiddie Town Kindergarten graduating class. Standing in the center of the next-to-top row is Matt Simmons, the youngest person to date elected to the office of mayor of Forest Park. Matt served as mayor from 1987 to 1990 and today is chief judge of the Superior Court of Clayton County. The picture to the left shows the city manager John Parker (left), who has served as Forest Park's city manager for more than 20 years, and Matt Simmons (right). (Above courtesy of the City of Forest Park; left courtesy of Matt Simmons.)

During 1969–1970, Forest Park was honored to have the girls' senior high basketball team named the State AAA Girls Basketball champs. Members of the Panthers from left to right are Kay Strickland, Deborah Robinson, Cheryl Howard, Debbie Purvis, Joan Butler, Delores Cole, and Jennie Babb. (Courtesy of Judy Strickland.)

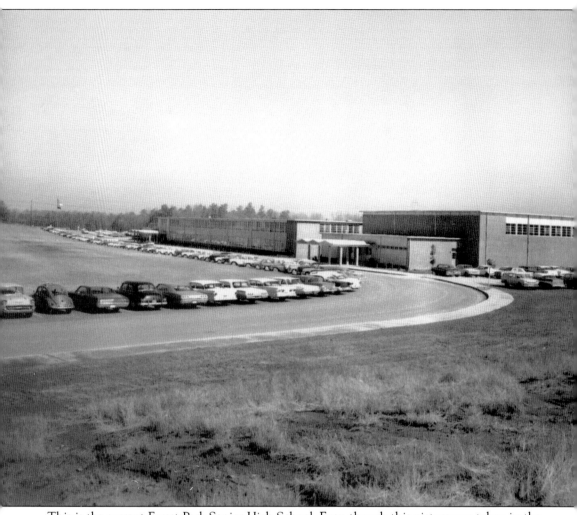

This is the current Forest Park Senior High School. Even though this picture was taken in the 1970s, the profile of the school has not changed drastically. The gym is the building on the far right, which is followed by the education wing. (Courtesy of City of Forest Park.)

Five

FROM DRY GOODS TO DRIVE-THROUGHS

Following the Civil War, it was difficult for the citizens of Forest Park to get back on their feet. When General Sherman and his troops came through on their march south, they destroyed homes, crops, businesses, and lives. Recovering took a lot of time and hard work, which the citizens of the city took on with pride.

Coming together as a community, families helped each other plant crops, build homes, raise church buildings, and start businesses. Buildings were occupied by two to three tenants, as in the case of the Masonic Lodge, Jim Crain's store, and the post office. Business relationships such as these were lifesavers.

In some cases, one individual would hold several jobs at one time, such as Henry Frances "Frank" Puckett. His occupations included postmaster, ticket agent, and first mayor of the city, and he was busy pumping water into the boilers on steam trains. He also reared a family and had a farm. This strong backbone was a necessity for survival. One of the first of its kind that the citizens might remember was J. J. Evans General Merchandise, the first brick building in Forest Park, which was on Main Street. The last tenants to occupy the building were Clayton County Federal Savings and Loan, then Heritage Bank. Sadly the building was hit by lightning and destroyed by the fire that ensued in 2000.

Smith Hardware was started in 1947. Its third and final location on Main Street was built in 1966 and was the first retail store in Forest Park to have an elevator.

So many businesses have been a part of Forest Park that to name them all would be impossible. They have all given Forest Park a place to shop, eat, play, or just hang out. The owners and employees have become friends and family. They provided safe places for the young people to go to without their parents worrying too much. Businesses were active in the community, sponsoring various events, having their own sports teams, providing moral support, and much more.

The smells, tastes, and feelings absorbed by citizens of this city will last forever in great memories.

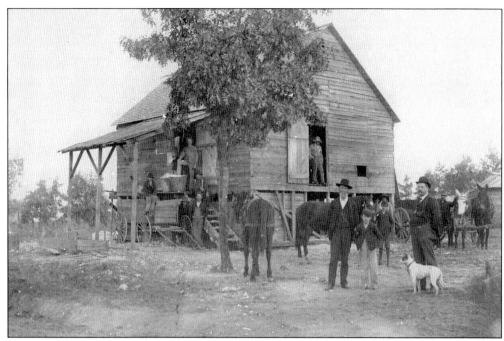

Standing in front of the cotton gin are, from left to right, H. F. Puckett, unidentified, and Lewis Yancey. In 1885, Alexander Lynn Huie sold 10 acres of land to his youngest son, Patterson Porterfield. This land contained a gristmill, cotton gin, homes, and other various structures. The price was as quoted: "P. P. Huie shall support and take care of A. L. Huie and his wife during their lives" (*History of Clayton County, Georgia 1821–1923*, page 300). (Courtesy of Beverly Barton Collins.)

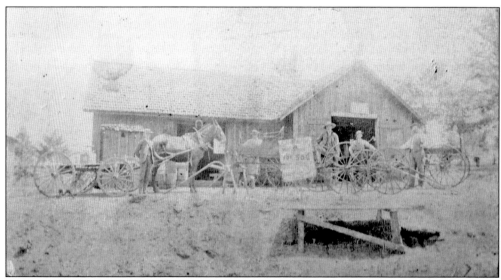

Forest Park's first blacksmith shop, located in the vicinity of College Street and Main Street, was operated by Dave Yancey. In 1908, the blacksmith shop moved to the back of a store located at Central Avenue and Lake Drive. This store was built in 1906 by Sam Yancey, who sold it to Jack M. Scott, who in turn sold the store to Jack George and Son in 1909. (Courtesy of Beverly Barton Collins.)

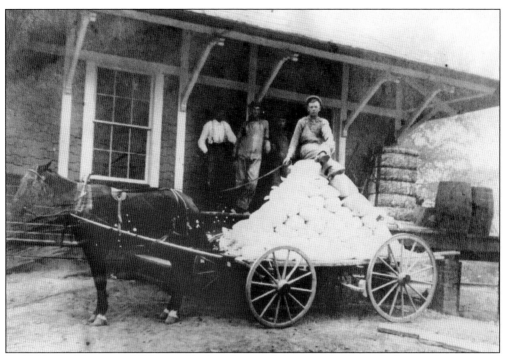

In 1846, the Macon and Western Railroad extended its tracks through the northern part of Clayton County with stops at Morrow's Station (Morrow), Quick Station (Forest Park), and Rough and Ready (Mountain View). With a final destination of the old Union Station in Atlanta, area farmers could send their cotton and other crops from their fields to locations in any direction. (Courtesy of the First Baptist Church of Forest Park.)

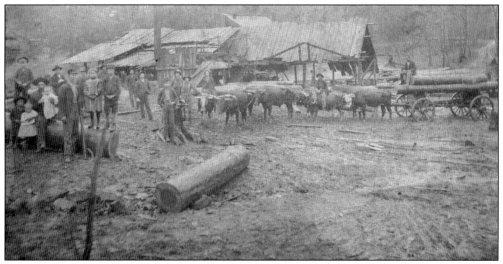

Forest Park's sawmill, built in 1901 is pictured here. It stood at the corner of Hill Street and College Street facing Main Street but was moved in 1907–1908. At this period, most citizens depended on their small farms to survive but also needed the means to process their raw materials. Therefore, the sawmill was operated by some of these farmers. Prior to this time, this property housed the railroad's section hands, the section foreman, and Dave Yancey's blacksmith shop. (Courtesy Beverly Barton Collins.)

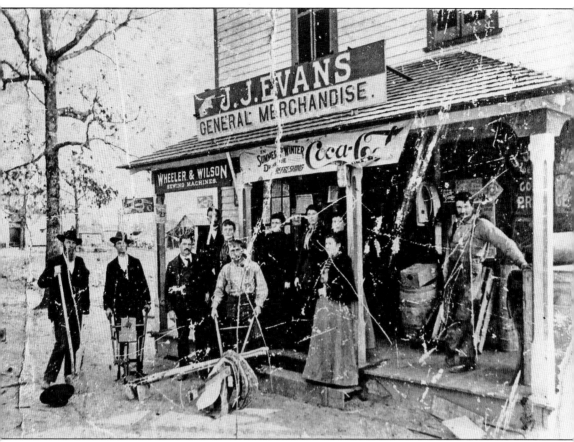

This photograph, taken between 1898 and 1903, shows Forest Park's first Masonic lodge building. A general store was located on the first floor and was originally run by Jim Crain. When Crain died in 1898, the goods in the store were bought by J. J. Evans, who operated the store until 1903. (Courtesy of the First Baptist Church of Forest Park.)

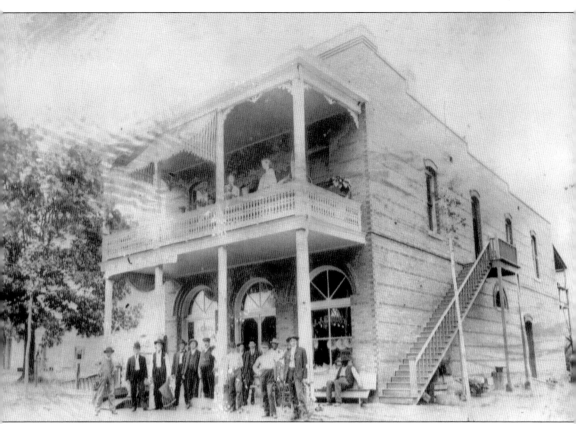

Julius Joseph Evans was born on December 10, 1865. He built the first brick building in Forest Park, J. J. Evans Mercantile Store. The building consisted of two stories, with the mercantile store and post office on the ground floor and an apartment on the floor above. The building was located on Main Street and was known as Coleman's Drug Store in the 1940s. Clayton County Federal Savings and Loan Association, then Heritage Bank, occupied the building until it burned down on June 22, 2000. Evans was also known for bringing the first automobile, an Auto Buggy, to the city in 1905. He and his wife would drive three miles to Morrow on Sunday afternoons to visit kinsfolk and friends. J. J. wore a John B. Stetson hat, and his wife wore a broad-brimmed silk plush hat with three ostrich plumes decorating it. On several occasions, they would begin their trip home only to find that the car would stick in the reverse gear. They could be seen driving this one-cylinder motor vehicle using a handle, not a wheel, down the road in reverse with the ostrich feathers blowing in the wind. (Courtesy of the Georgia Archives, Vanishing Georgia Collection, image no. clt043-84.)

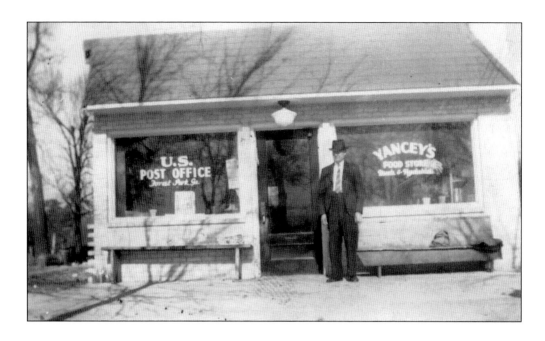

Built in 1908 by brothers S. C. (Sam) and W. L. (William Lewis) Yancey, Yancey's Food Store and Forest Park Post Office was on the northeast corner of North Lake Drive and Main Street. The post office was operated by Iva Lena Puckett Yancey, the daughter of the city's first mayor. The top picture shows one of the brothers standing in front of the store in the 1940s. In the picture below, Miriam Farmer (right) and Stella Reed Sheppard (left) are standing outside the post office. (Above courtesy of Judy Strickland; below courtesy of Miriam Farmer.)

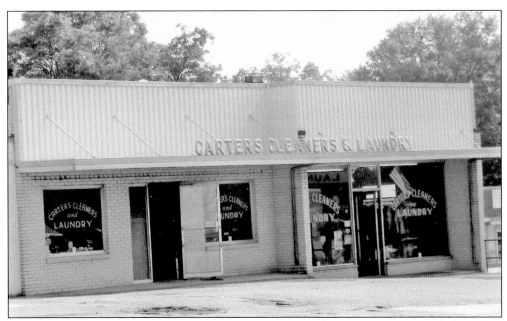

Carter's Cleaners and Laundry has long been a mainstay in the community. Not only have they outlasted other cleaners who couldn't meet the standards, but they are also supporters of the community, frequently sponsoring little league teams and sports programs. If it has anything to do with education, the Carters are in support of it. Their outside sign always shares recent community news or words of inspiration and always displays the word "pray" on one side of the board. (Courtesy of Mike Carter.)

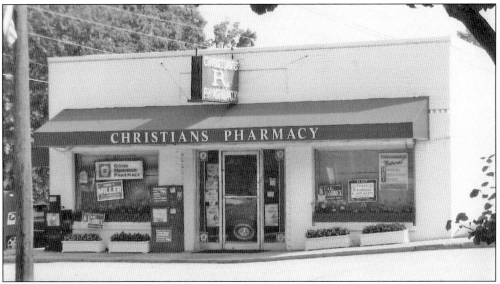

Dr. George "Doc" Christian is a man known and loved by many. His drugstore saw the soda fountain years with many of the kids around working as soda jerks, wooden phone booths in the corner of the store, and miles of parades passing by. Located across from the pediatrician's office, he helped Forest Park children overcome any illness conceivable. Today the store is owned and operated by John Chafin, who was trained well by Doc. Doc is enjoying a well-deserved retirement, living on a lake and fishing all day. (Courtesy of City of Forest Park.)

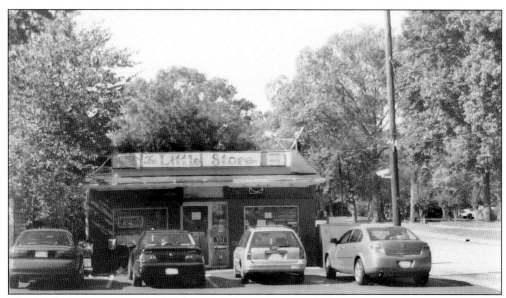

The Little Store may not look like much from the outside, but it is a unique neighborhood convenience store that has been in business for what seems like forever. Aubrey Lee opened the store, and it is thought that three other owners have kept the store open. (Courtesy of City of Forest Park.)

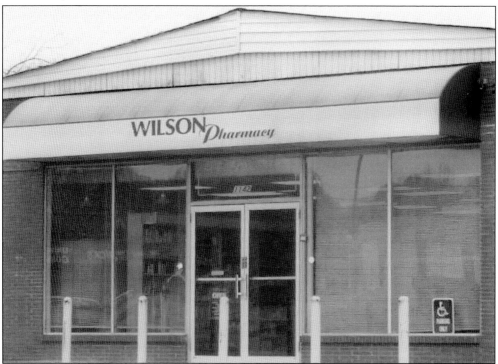

Wilson Pharmacy has been another mainstay in Forest Park. Having moved several times up and down Main Street, it is settled into a great building near Jonesboro Road. Even with another privately owned drugstore, two chains, and others that have come and gone, Wilson Pharmacy still survives. (Courtesy of City of Forest Park.)

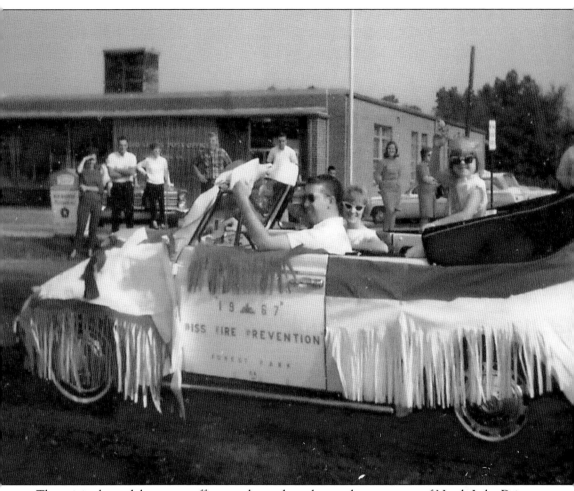

The original standalone post office was located on the northwest corner of North Lake Drive and Main Street. This picture shows the post office in October 1967 while the Fire Prevention Week parade passes by. To celebrate the close of the week, a Miss Fire Prevention contest was held. Riding in the back of a white Volkswagen convertible is Sandra Evans from Little Ones. (Courtesy of City of Forest Park.)

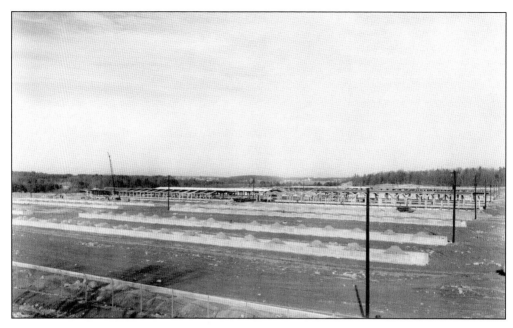

The farmers market first started in Atlanta in 1912 where the current city hall is located and was known as Produce Row. In 1941, 16 acres on Murphy Avenue became the official location of the farmers market. Due to its success, traffic congestion, and inadequate facilities, it moved onto 146 acres of land in Forest Park. The initial plans included 16 farmer sheds, 9 wholesale dealers' buildings, an administration building, the hamper house, a cannery, a service station, and two restaurants, at a price of $10 million. (Courtesy of Murphy and Orr Exhibits.)

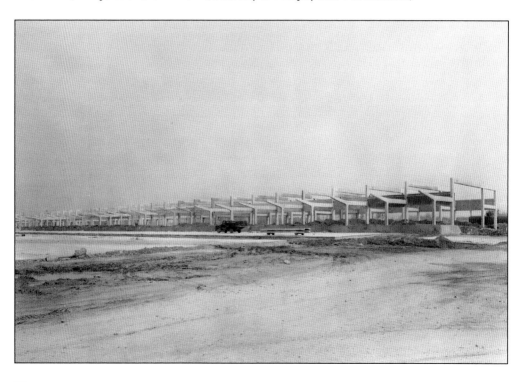

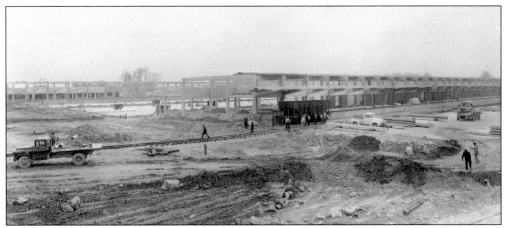

On September 4, 1956, grading began for the Georgia State Farmers Market. When construction was completed in 1959, it was said to be the most modern farmers market in the country. The sheds and buildings, 32 in all, were made of ageless, fireproof concrete. Today the market is one of the largest open-air markets in the world. (Courtesy of Murphy and Orr Exhibits.)

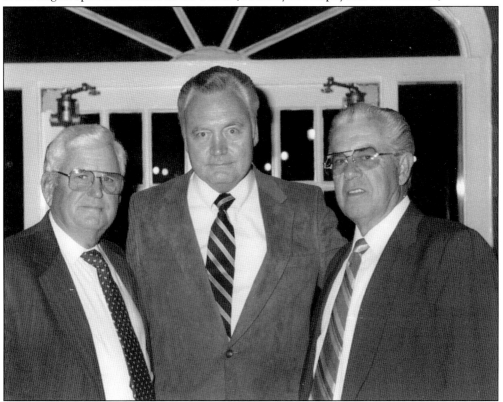

Forest Park is proud to be the home of the Georgia State Farmers Market. Gene Sutherland of Sutherland Eggs, Inc., is seen standing between Georgia state representative William "Bill" Lee (left) and Georgia state senator Terrell Starr (right). Both Lee and Starr are from Forest Park and have contributed much of their lives to making the city a better place. The city has honored these two gentlemen by naming separate parks for them in the downtown area of the city. (Courtesy of Marsha Thomas, Atlanta Produce Dealers Association.)

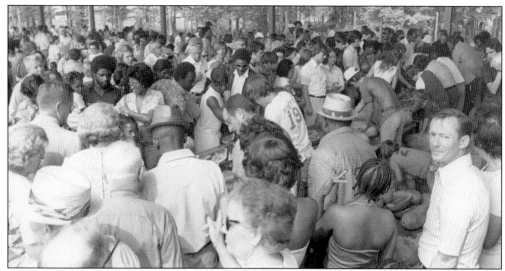

Watermelon Day was sponsored by the Georgia State Agriculture Department and was usually scheduled on the Sunday before Independence Day. Country music was the highlight of the day, but participants could also enjoy celebrity guests, great food, and games for the whole family. (Courtesy of Murphy and Orr Exhibits.)

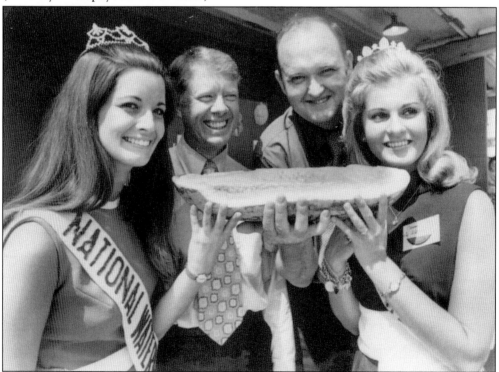

In 1971, Watermelon Day festivities at the Georgia State Farmers Market drew huge crowds. As shown in this photograph, then-governor Jimmy Carter and agricultural commissioner Tommy Irvin welcomed the national and state watermelon queens. Activities at the festival included no-hands watermelon-eating contests, visits from national and local celebrities, and much more. (Courtesy of Murphy and Orr Exhibits.)

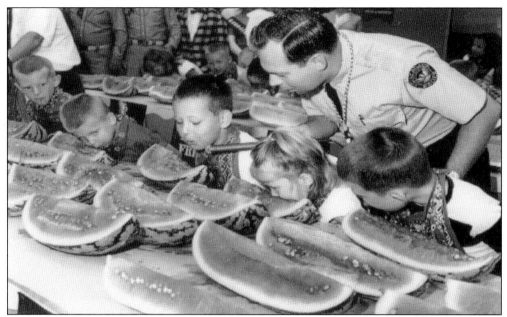

This photograph shows the no-hands watermelon-eating contest. With bandanas tied around their neck to catch watermelon juice before it hits their shirts, the children dig in face-first to see who can eat the most watermelon in an allotted time period. Local children's television host Officer Don interviews a contestant. (Courtesy of Marsha Thomas, Atlanta Produce Dealers Association.)

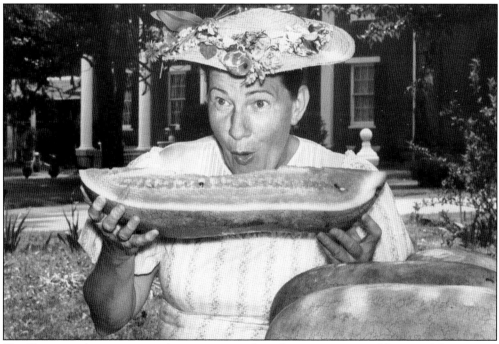

Hee-Haw was a long-running television variety show featuring music and humor of the country variety. Minnie Pearl, with her straw hat and its $1.98 price tag, poses at one of the watermelon festivals. She was just one of the cast members from the show to make an appearance. Junior Samples also appeared at one of the festivals. (Courtesy of Murphy and Orr Exhibits.)

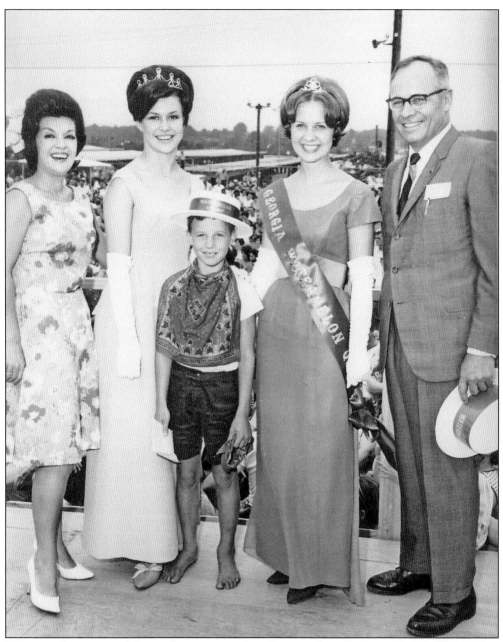

Numerous big-name celebrities have appeared at Georgia State Farmers Market Watermelon Festivals, including Porter Wagoner, Norma Jean, Curley Harris, and the Wagonmasters. Shown in this photograph is Elsa Miranda. During 1945–1946, she was one of the most popular "Miss Chiquita" models. Born in Puerto Rico, she made personal appearances on behalf of the Chiquita brand in movies, commercials, and even with Arthur Fiedler and the Boston Pops Symphony Orchestra. Pictured from left to right are Elsa Miranda, Pam Belson (national watermelon queen), Hubert Smith Jr. of Roswell (winner of the watermelon-eating contest), Mary Sue Zipperer (Georgia watermelon queen), and Georgia agricultural commissioner Campbell. (Courtesy of Marsha Thomas, Atlanta Produce Dealers Association.)

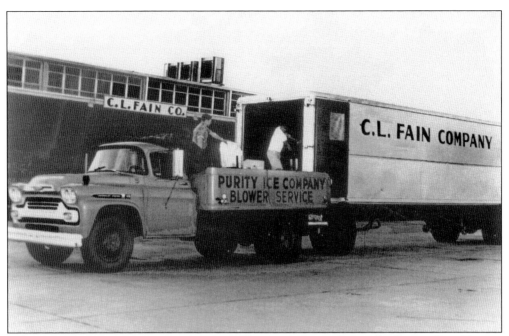

Delivery trucks from Purity Ice Company were often seen icing produce at the Georgia State Farmers Market to be readied for shipment. Pictured in front of C. L. Fain Company are Lynn Wells and his son, Van, who represented the third and fourth generations of Wells to operate the ice plant. C. L. Fain was one of the first merchants to rent space at Produce Row in Atlanta. Produce Row vendors moved to new, modern facilities at the market in 1959. (Courtesy of John Gillon.)

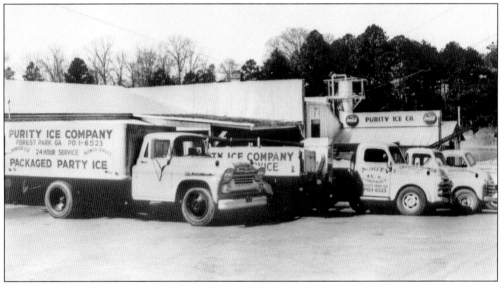

The ice plant was built by E. J. Wells in 1926. Purity Ice Company's plant on Astor Avenue was capable of producing 20 tons of ice per day, which was delivered to the Conley Depot (now Fort Gillem), Forest Park, Clayton County, and the surrounding areas. Water to make ice came from Waldrop Spring, an artesian well on the site. Ice was manufactured in 300-pound blocks and chopped into smaller crushed pieces for packaged party ice. (Courtesy of Georgia Archives, Vanishing Georgia Collection, image no. clt045-84.)

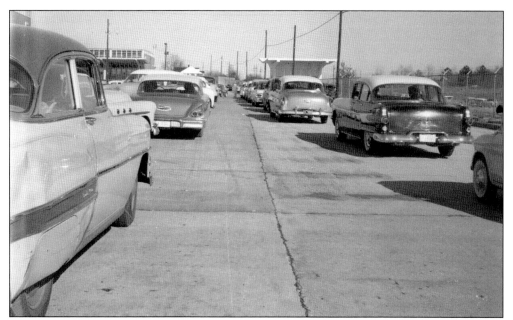

The Georgia State Farmers Market is managed and operated by the Georgia Department of Agriculture. Seen here entering the market is a stream of vehicles and their occupants, who are ready to make a selection of fresh fruits and vegetables. Many people visit the market on a regular basis, including weekly, monthly, or yearly visits. Officials calculate an average of over 3,500 people come to the market each day. (Courtesy of Murphy and Orr Exhibits.)

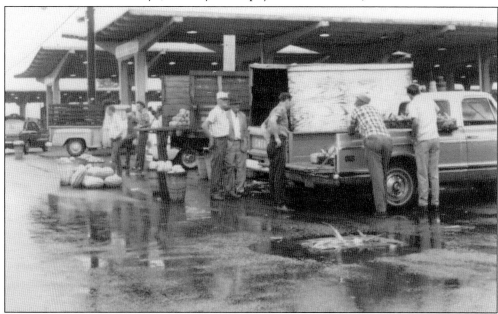

Farmers would bring produce to the Georgia State Farmers Market, unload, and set up on one side of the shed, while shoppers drove down the other side, deciding what to buy. The routine for some families was that men would drive the wife and kids to the market, and the kids would get out of the car and walk around to see who they knew while the husband would slowly drive the wife around, stopping to let her buy what she needed. (Courtesy of Murphy and Orr Exhibits.)

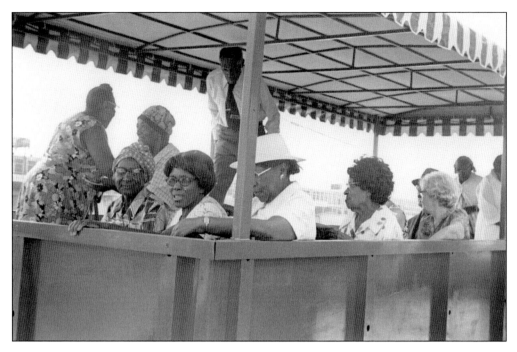

In the early 1980s, special tours of the Georgia State Farmers Market could be arranged for groups. The trolley was named "Fresh Express" and was pulled by a tractor around the market to give visitors a fun way to view the fresh produce. The wait to board the trolley was worth it, with stops at the stalls, the hamper house, the cannery, gardening sheds, and possibly lunch at Davis Brothers Cafeteria (now Oakwood Café). Parking at the individual stalls can sometimes be a problem, and the market is definitely too big to go it on foot. (Courtesy of Murphy and Orr Exhibits.)

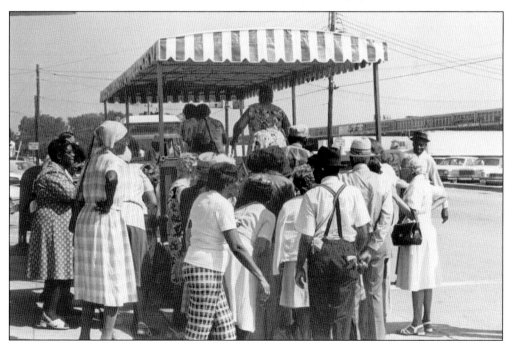

Sutherland Eggs, Inc., began operation in 1947 on Murphy Avenue in Atlanta. Leaving his job working in the dairy section of Kroger, Mr. Sutherland started his own egg distribution company. His son, Gene, began helping his father when not in school and joined the company full-time in 1953. (Courtesy of Sutherland Eggs, Inc.)

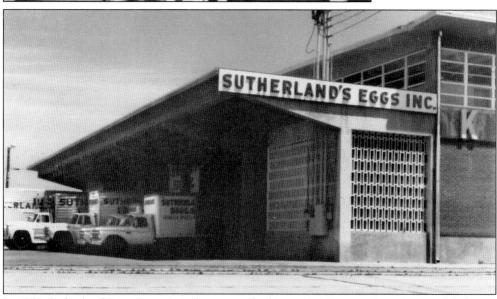

In 1959, Sutherland Eggs, Inc., moved to a new facility at the Georgia State Farmers Market in Forest Park. The company has expanded several times over the years, making it the largest facility housed at the market, with the recent addition of an institutional grocery business. (Courtesy of Sutherland Eggs, Inc.)

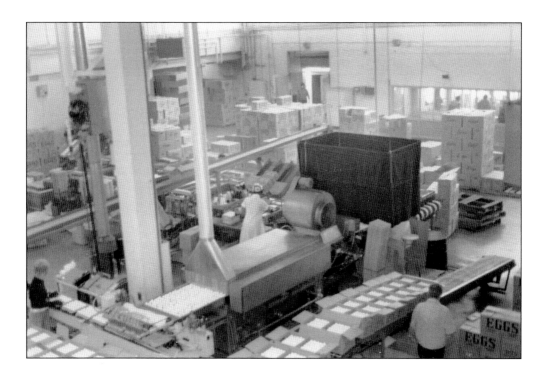

This is a view of the egg production floor of Sutherland Eggs, Inc. In the early days, the process involved putting the eggs through a wash and checking each individual egg by holding it up to a red light, which illuminated the inside of the egg so an individual using only the human eye could see any imperfections. As the business grew, a modern machine was installed that shone light up from under the egg. This eliminated the need to handle each egg individually. As the eggs passed by, a person would watch the process, removing an egg by hand if it did not meet standards. After this, the eggs were sorted, graded, and packaged. The finished product shown below is ready for shipment. (Courtesy of Sutherland Eggs, Inc.)

ICE PLANT RD
(Forest Park Ga)

(1) ★ Purity Ice Co...........CA-6523
 ★ Sikes R J r............CA-4693
 ★ Stone Anne Miss r......CA-1259

Although shown on different maps drawn through the years as Astor Avenue, the Southern Bell Telephone and Telegraph Company Street Address Telephone Directory of June 1947 listed Purity Ice Company as being on Ice Plant Road in Forest Park. Astor Avenue was not listed in this book. (Courtesy of Barbara Dunn.)

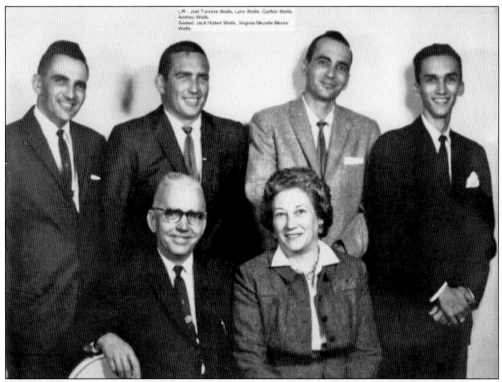

Many members of the Wells family worked at the plant over nearly six decades of operation. One of E. J. Wells's sons, E. Lee Wells, moved to Atlanta to join the South's largest ice company, Atlantic. He rose through the ranks to become secretary and treasurer of Atlantic Ice. One of E. J. Wells's great-grandsons, John Wells Gillon, after working at Purity Ice Plant for five summers, became manager of the Atlanta Ice Plant in Winston-Salem, North Carolina, in 1976. (Courtesy of John Gillon.)

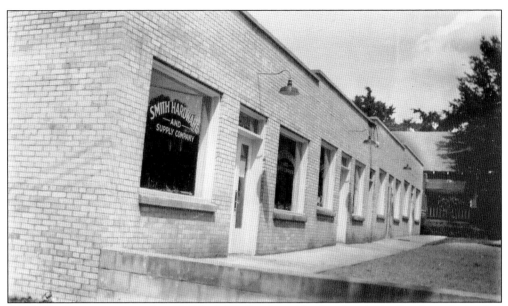

Smith Hardware was started in 1947 by J. W. Smith and his brother, Mike Smith, with the first store located on Main Street between West Street and North Oak Street, across Main Street from William H. (Bill) Lee Park. Mike ran the store while J. W. continued to work downtown to bring in money. In order to cut cost, only one of an item would be placed on the shelf in front of its container, making it look like the store had twice the stock. When sold, J. W. would restock that item with one he bought from the store he worked in. Below is a view of the inside of the hardware store with J. W. hard at work. (Courtesy of Debbie Bray.)

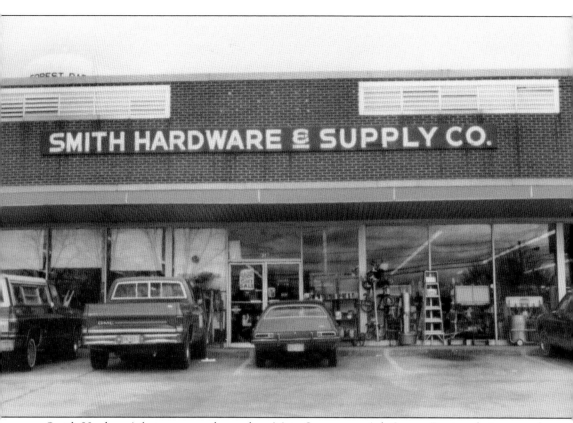

Smith Hardware's last store was located on Main Street near Ash Street. During their years of business, the Smith boys sold a multitude of products ranging from tricycles and red wagons to cookware and, of course, hardware. Smith Hardware closed for good in October 2006 to the dismay of many. (Courtesy of City of Forest Park.)

This building is located on Main Street and has touched many lives. Although tenants have included grocery stores, upholstery shops, printers, and a hardware store, most people associate this building with the name Tomasello. Jerry and Montine Tomasello ran an accounting office in this location for over 50 years. Visiting the tax office was an enjoyable experience, even if the reason for the visits was dreaded by all. Many clients returned year after year, so not only were people able to see the Tomasellos, but they also would often run into old friends from years gone by. (Courtesy of City of Forest Park.)

This is a picture of the Forest Park Post Office. The mail system in Forest Park evolved from a bag being thrown off a steam locomotive train, to a post office in the front room of the postmaster's house, to part of two general merchandise stores, and finally to its first free-standing, single-occupancy building. This is the second building occupied by only the post office, and it has stood strong for approximately 30 years. (Courtesy of City of Forest Park.)

Murphy and Orr Exhibits was established in 1946 and is one of the nation's oldest producers of exhibits. With clients including educational institutions, corporations, museums, and other organizations, Jerry Murphy and his team of approximately 50 people have produced exhibits, permanent displays, visitor centers, and museum displays. All products are designed and fabricated to museum-quality specifications and are fabricated, finished, and reassembled on-site by Murphy and Orr personnel. (Courtesy of City of Forest Park.)

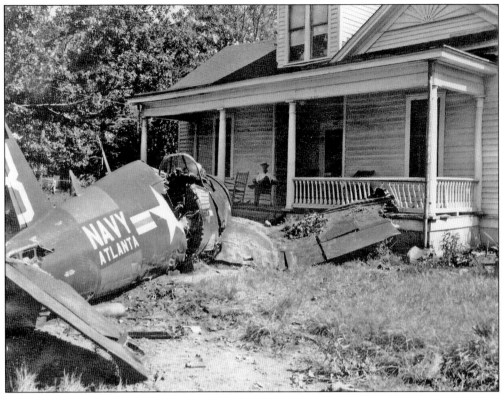

In 1956, a transportation supply section on the base at Fort Gillem provided field maintenance back-up supplies to army aircraft in the Third Army area. In 1957, a 3,000-foot paved runway and 20,000-square-foot shop for repairs were completed. In 1959, the airfield was named the Morris Army Airfield in honor of 1st Lt. John O. Morris Jr. Morris was an army pilot killed at Thule Air Base in Greenland in 1955 when his helicopter crashed. (Courtesy of Fort Gillem Archives.)

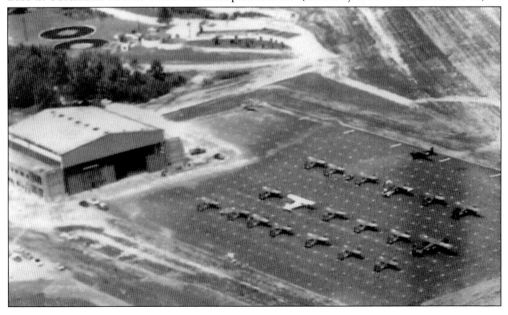

Fort Gillem Military Reservation is located on 1,465 acres of land in the northeastern part of Forest Park. Official duties of the fort include training thousands of supply soldiers and maintaining and processing tons of equipment used in every major conflict since World War II. Responsibility for Fort Gillem first fell under the U.S. Army Materiel Command but was transferred to U.S. Army Forces Command in June 1973. Established in 1941, the base encompasses not only warehouses and older brick buildings, but also two lakes, a tennis court, a playground, a softball field, and a golf course. First named Atlanta Army General Depot and located in Atlanta at the Candler Warehouse, the name was officially changed in June 1974 to Fort Gillem in honor of Lt. Gen. Alvan C. Gillem Jr. (1888–1973). Beginning his career in 1910 at Fort McPherson, he retired as the commanding general of U.S. Third Army, having served his entire 40 years at the same post. (Courtesy of the Patton Museum of Cavalry and Armor, Fort Knox, Kentucky.)

Six

THE FINAL CHAPTER

This chapter contains a menagerie of photographs taken throughout the history of the city. Hopefully the maps included will help explain the location of the various areas mentioned in the book.

A lot of memories were not included, mainly due to shortage of space. But to introduce the final chapter, here are some of the stories not accompanied by photographs.

Kids would light cigarettes and use them for lighting firecrackers, ensuring a clean getaway. Three boys were accused of stealing, put in the back of police cars, and driven to the police station. Two of the boys were innocent, according to the one who became a lawyer, and the third one wasn't charged because the chief was also his coach. Then there were the adults. At one gas station, the owner would make a bet on whose soda traveled the farthest. What the customer did not know was the owner also stocked the machine and had alternated the locations on the bottles, with every other bottle being from Atlanta. Guess who always got the last laugh?

Some good memories include the following. Students would get out of a school function and go to Dipper Dan's for ice cream. It was in the corner of the Grant's shopping center, next to the Bradford Room. There was also the skating rink and the theater, the drive-in on Jonesboro Road at I-285, Shoney's, Richway, Treasure Island, and Zayres. Hopefully some old memories, wonder, curiosity, and laughs are held in this page and pages following, waiting to be discovered.

Some of the people who have worked for the City of Forest Park are pictured, allowing one to be grateful of how far the town has come. Look closely, not only at the pictures in this chapter, but all the photographs in the book. Someone familiar might be staring back. Enjoy the walk back in time. Forest Park always welcomes visitors. Please remember that the citizens of this city are a family, and as such, they still take lots of family pictures, so remember to smile.

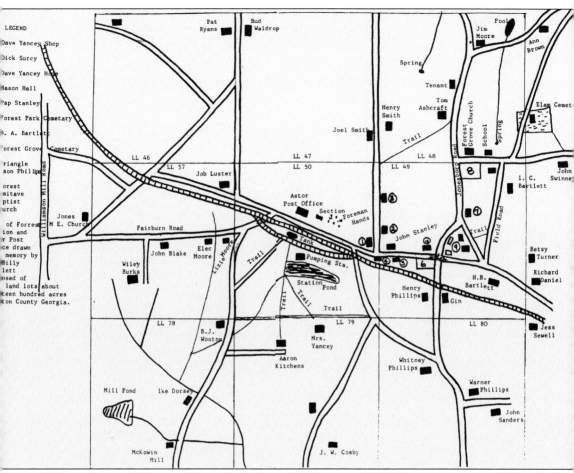

This is a layout of the city of Forest Park, then called Astor, in 1897. The map was originally hand drawn by early resident W. I. "Billy" Bartlett. In the 1960s, Billy sat down with pen and paper and drew from memory what the city was like. D. B. Crawford took Billy's copy and produced this version. Billy's map was part of a story he wrote titled *As I Remember*. This story has been invaluable in the writing of this book. (Courtesy of Ginny Callaway.)

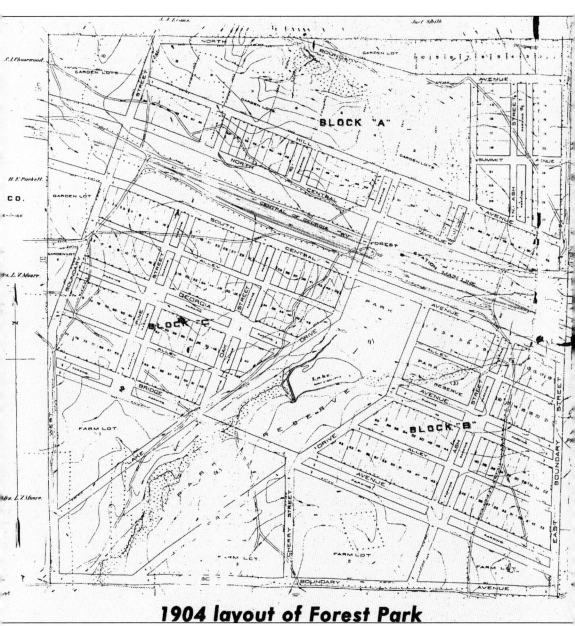

1904 layout of Forest Park

This map of Forest Park was found by employees of the city's recreation department. It shows how the land was divided in 1904. During this time, the train depot was called Forrest Station, Main Street was known as North Central Avenue, and there were farm lots, garden lots, homes, and lakes all nestled within one square mile. In the center of the picture is an area labeled "Park Reserve." The lake in the reserve was fed by a natural spring and was used by the railroad to fill boilers on steam engines. The lake has since been filled in, and the park reserve has been named Starr Park in honor of former senator Terrell Starr. The park provides access to a walking track, playground, ball fields, an outdoor swimming pool, and much more. Enjoyed all year long, it is a beautiful asset to the community. (Courtesy of Glenn Worley.)

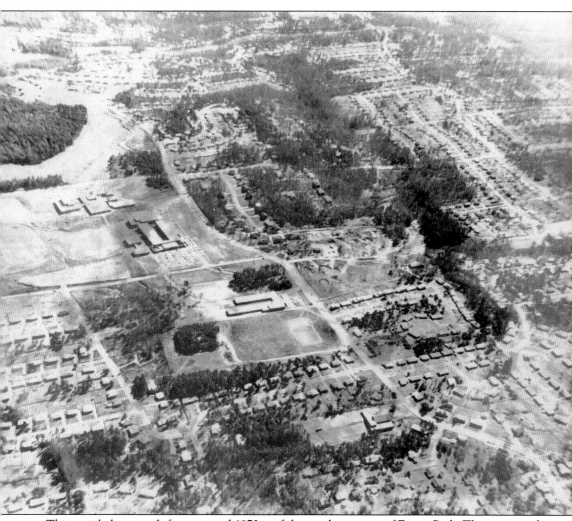

This aerial photograph from around 1970 is of the southeast area of Forest Park. The main road on the right side of the picture is Phillips Drive. Moving up from the bottom right corner of the picture is the Church of Christ. The vacant land toward the center of the picture is where Jones Memorial Methodist Church is today, then Lake City Elementary School, Forest Park Senior High, and Babb Junior High. (Courtesy of Jones Memorial First United Methodist Church.)

In 1907, Forest Park was treated to a show by Haley's Comet. In *As I Remember*, W. I. Bartlett recalls, "I have seen several pictures and dates of this wonderful thing but as far as I am concerned it was in 1907, and this picture is the most like it of any thing that I have seen . . . all of that year, it was there and then that I saw this wonderful thing called Halley's Comet. This picture should be kept and compared to the next one in 1982." (Courtesy of City of Forest Park.)

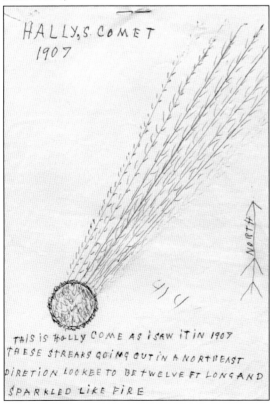

This photograph was taken on March 14, 1924, and shows what might be the auditorium at Forest Park. Citizens have passed down the location's whereabouts as being in the area of Ash Street and Park Avenue. Pete Castle, a blind country music singer, once performed here. The structure was also used for suppers, dances, and once promoted a boxing event where locals could spar a few rounds. The building was heated with a wood stove, had wood floors, and sat up off the ground on cornerstones. (Courtesy Beverly Barton Collins.)

On March 14, 1924, Forest Park saw a heavy snowfall. Henry Frances "Frank" Puckett is seen holding a snowball in each hand, ready for battle. He owned a beautiful lot on Main Street west of downtown that made for a beautiful winter scene. (Courtesy of Beverly Barton Collins.)

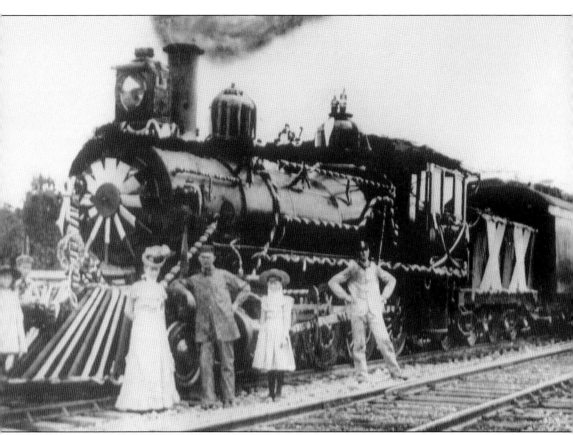

In 1846, the Macon and Western Railroad extended its tracks through the northern part of Clayton County with stops at Leaksville (Jonesboro), Morrow's Station (Morrow), Quick Station (Forest Park), and Rough and Ready (Mountain View). Quick Station earned its name during the Civil War because soldiers were able to go from the train to the woods quickly without being detected by Northern troops. When the railroad had depleted the supply of wood, the town was nicknamed Stump Town due to the tree stumps left by the railroad. In 1901, the railroad subdivided 200 acres at Stump Town and sold off the land. The name of the railroad station became Forrest Station, and because the railroad had designed the town with wide, well-planned streets with a park area in the middle of each, the town was named Astor. (Courtesy of Beverly Barton Collins.)

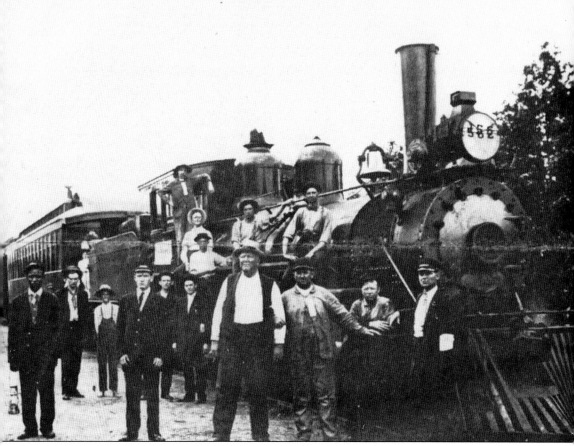

The first train was nicknamed the "Dummy" by people in the area, because there was no roundhouse in Jonesboro for the train to turn around in, so the train had to run backwards on its return trip to Atlanta. (Courtesy of Beverly Barton Collins.)

This photograph shows line foreman Mr. Welch and his crew. Their job was to maintain a certain section of the railroad tracks. Atlantic-Macon Railroad ran passenger and freight trains through the city, so safe tracks were very important. Pictured from left to right are Mr. Welch, E. Middlebrooks, N. Davis, A. Norrington and S. G. Souder. Section foremen lived in the Main Street and College Street area, with their workers living around the area of Main Street and North Lake Drive. (Courtesy of Mattie Hartsfield.)

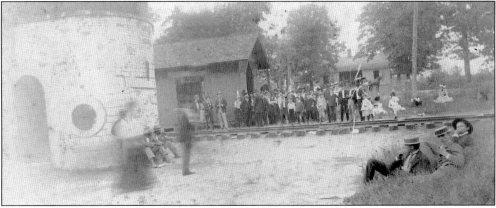

In 1901, the railroad saw the need for passenger service in the area, and since the train already stopped for wood and water at Forrest Station, it decided to build a depot on this spot as well. The first depot was simply an open woodshed built to provide shelter while a new depot was being built. The new depot was about 6 feet wide and 10 feet long, with openings for a window and door at each end of the building. The next depot was built in 1903 and was state-of-the-art because it had a telegraph office inside with an operator whose name was Kenny. (Courtesy of Beverly Barton Collins.)

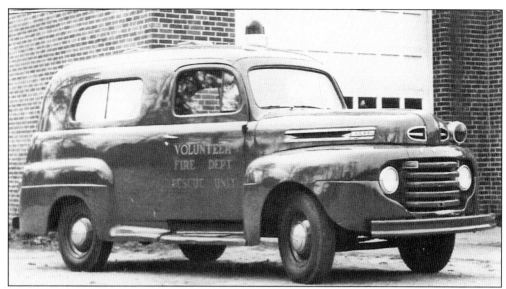

Shown above is the first ambulance, the Volunteer Fire Dept Rescue Unit, used by Forest Park in the 1950s. Volunteers served as the city's firefighters until 1962, when all firefighters became fully paid. Today the city has two fire stations equipped with five rescue units. (Courtesy of City of Forest Park.)

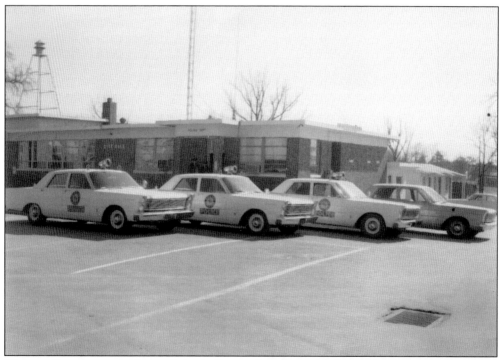

These police cars are in front of city hall on today's Forest Parkway. At that time, the police station was at the west end of city hall near Lake Drive. Today Forest Park Archives and Forest Park Support Services occupy the space. (Courtesy of City of Forest Park.)

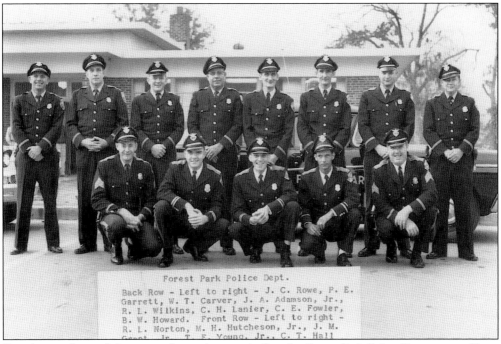

Standing in front of the station located in city hall is the Forest Park Police Department. From left to right are (first row) R. L. Norton, M. H. Hutcheson Jr., J. M. Grant Jr., T. E. Young Jr., and C. T. Hall; (second row) J. C. Rowe, P. E. Garrett, W. T. Carver, J. A. Adamson Jr., R. I. Wilkins, C. H. Lanier, C. E. Fowler, B. W. Howard. (Courtesy of City of Forest Park.)

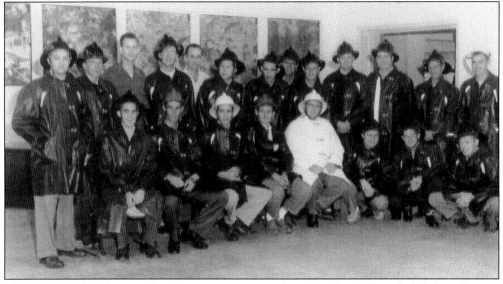

The Forest Park Volunteer Fire Department, pictured on May 21, 1955, included the following members: Jesse M. Grant, Byron Winslett, Lester W. Boswell, Chief Robert E. Johnson, Robert L. Norton, William J. Guice, Edmund D. Brown, Louie Ezell, Charles L. Chatham, John H. Chamlee, J. P. Newborn, Frank Richardson, R. G. Hornsby, Roy Echols, D. R. Stewart, William "Jack" Hobbs, Walter "Jack" Curtis, Clarence Lanier, Paul Bedingfield, and LeRoy Walker. (Courtesy of City of Forest Park.)

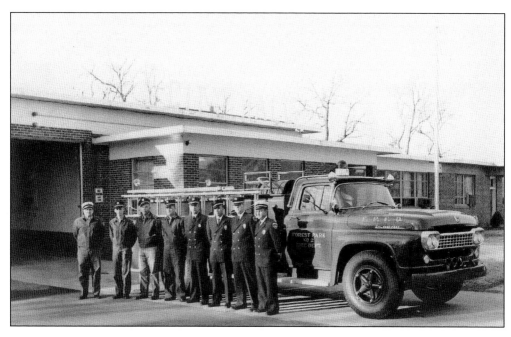

The photograph above was provided by Bob Hammond and shows Forest Park's first fire station in 1959. The fifth fireman from the left is Bob, who would become the city's fire chief. When this picture was taken, the fire department was located on the east end of city hall (now the Planning, Building and Zoning Department). The bottom photograph, provided by the City of Forest Park, shows Station 1, the next station, and some of the equipment in use at the time.

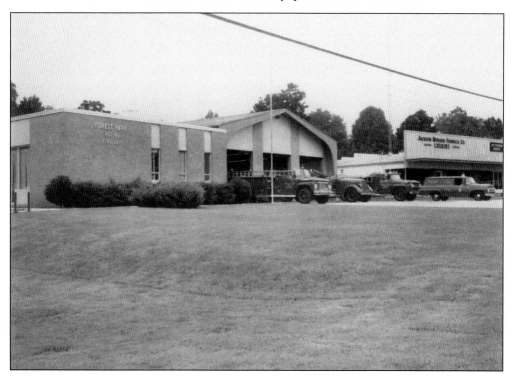

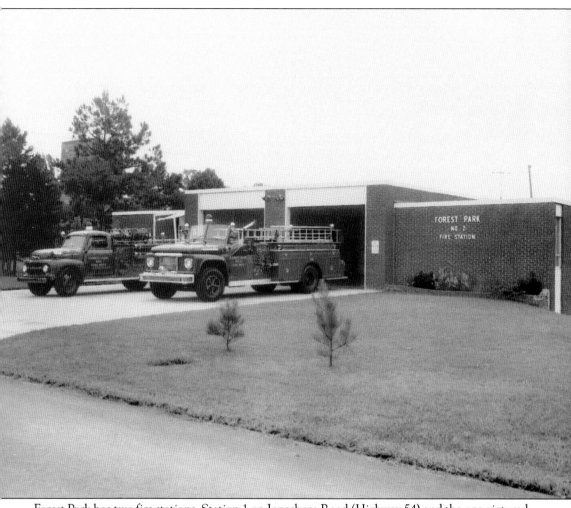

Forest Park has two fire stations, Station 1 on Jonesboro Road (Highway 54) and the one pictured here on Linda Way, near Ash Street. Station 2 is used as a training facility and is complete with a burn tower built by the firefighters themselves. This tower is equipped with high-tech features such as collapsible floors and can simulate trapped individuals. (Courtesy of City of Forest Park.)

Taken in 1982, these photographs show Starr Park, located behind the police station, which is now the Agnes Bateman Community Development Building. Many changes have taken place since these photographs were taken, including up-to-date equipment on two playgrounds, one for small children and the other for older children. New equipment was installed in 2007, complete with recycled rubber ground cover for a soft landing if someone should fall. (Courtesy of City of Forest Park.)

This is the view of Forest Parkway and Lake Drive in 1982. The large white building in the center of the picture is city hall. Also of note are the railroad tracks. The tracks closest to the parkway were the spur tracks used when loading and unloading trains. The depot would have been located approximately at the bottom of the picture. (Courtesy of City of Forest Park.)

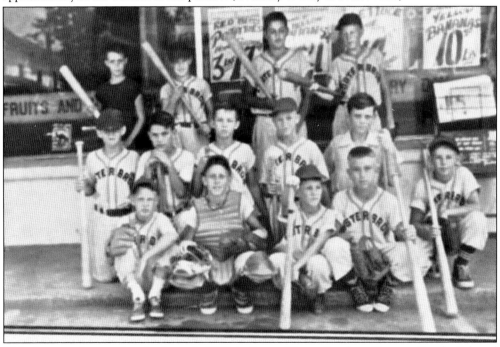

This photograph was taken in the early 1950s in front of Foster Brothers Grocery. Run by Eck and Walter Foster, this store was located on Main Street near the intersection of Main and College Streets. Pictured from left to right are the following: (first row) Alvin Foster, Micky Murphy, Glen Baker, and two unidentified; (second row) unidentified, Don Foster, Tommy Grant, Butch Baker, and unidentified; (third row) Mark Taylor, unidentified, Larry Foster, and unidentified. (Courtesy of Don Foster.)

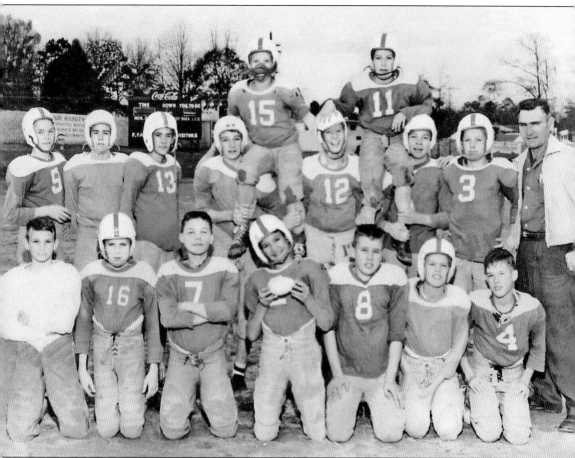

Forest Park was a great place for young people to grow up. Don Foster, no. 7 in the front row, and Herschel Smith, a former citizen raised in the city, both said living in Forest Park was like living in Mayberry. Parents could let their children leave the house to explore the city and feel confident that no harm would come to them. Everyone knew everyone, and neighbors watched out for one another. Photographed around 1953, from left to right, are the following: (first row) Jan Klaus, Butch Beaty, Don Foster, Danny Martin, Gene Byrom, Kenneth Hart, and ? Cox; (second row) John David "Butch" Baker, David Hart, Billy ?, Fred Bishop, Mike Muskidelly, Tommy Grant, Gene Johnson, and coach J. L. Baker; (third row) Benny Lopez and Glenn Baker. (Courtesy of City of Forest Park.)

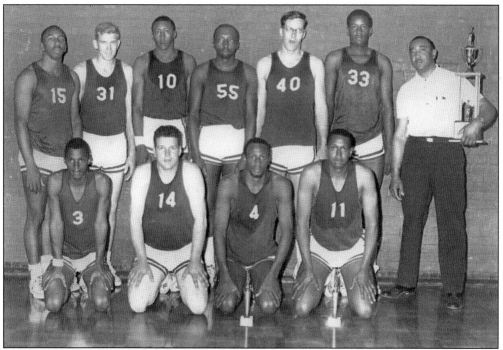

The dates of these snapshots are unknown, and the players are unidentified. They are representative of the kids who played on the many teams available in Forest Park. From opening day to the final play of the season, all residents were fans of the game. With names like Jack Aaron, Ray Bryant, Lamar Shields, Hines Ward, Larry Foster, Skippy Sanders, and many more, the city is very proud of its sports heritage. Whether in the school system or city-sponsored leagues, these individuals did their best and left the city proud and amazed. (Courtesy of City of Forest Park.)

Forest Park takes sports very seriously, starting with little league, where the team won the Pee Wee Reese World Championship. The city also had the honor to host the series for several years, including its championship year. Other teams, such as the swim team, have earned greatness in their field as well as spawning great individuals. This photograph was taken at a swim meet in 1967. These students also had great parents to support them. Mothers and fathers were always on the sidelines or working behind the scenes to cheer on their children. (Courtesy of City of Forest Park.)

These two photographs show Jean Perry (center below wearing flowered blouse) and Bill Perry (congratulating a winner at right). Bill served as meet manager of the Georgia swim meet held at Forest Park Recreation Center in 1972. Their son, Glen Perry, was a contemporary of Steve Lundquist, an Olympic gold medalist. Steve's father, Bob Lundquist, served as clerk of the course. The two boys were evenly matched in talent and would often challenge each other in head-to-head competitions, each taking their share of the winnings. Glen and Steve would have both participated in the 1980 Olympic Games if the United States had not pulled out. Steve went on to participate in the 1984 Olympic Games, taking two gold medals in the 100-meter breaststroke race and the 400-meter medley relay. Still living in the area, he is very active in the community and runs his own business. (Courtesy of City of Forest Park.)

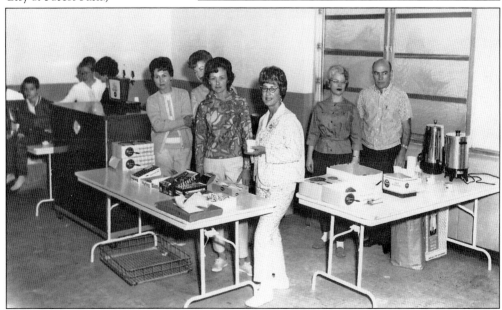

ACROSS AMERICA, PEOPLE ARE DISCOVERING SOMETHING WONDERFUL. THEIR HERITAGE.

Arcadia Publishing is the leading local history publisher in the United States. With more than 4,000 titles in print and hundreds of new titles released every year, Arcadia has extensive specialized experience chronicling the history of communities and celebrating America's hidden stories, bringing to life the people, places, and events from the past. To discover the history of other communities across the nation, please visit:

www.arcadiapublishing.com

Customized search tools allow you to find regional history books about the town where you grew up, the cities where your friends and family live, the town where your parents met, or even that retirement spot you've been dreaming about.